PIGS & INGOTS

PIGS & INGOTS
THE LEAD/SILVER MINES OF CARDIGANSHIRE

TINA CARR & ANNEMARIE SCHÖNE

First impression: September 1993

© Y Lolfa Cyf., 1993

ISBN: 0 86243 286 3

Printed and published in Wales
by Y Lolfa Cyf., Talybont, Dyfed SY24 5HE;
tel. (0970) 832 304, *fax* 832 782.

Roman Lead Pig. 22½″ long, weighing 152 lbs, Pennant,
'Tours of Wales' Vol.1.

CONTENTS

ACKNOWLEDGEMENTS

We would like to thank the following: Jen Green for invaluable editorial help and advice, Dyfed Archaeological Trust for their encouragement and support throughout—especially Terry James. Barbara Harrison for typing the first draft of the manuscript. The staff of the National Library of Wales—especially Iwan Jones, Assistant Keeper in the Department of Pictures and Maps. Last, but by no means least, the staff of Carmarthen Library for their enduring patience and good humour.

The photography initially had financial support from The Photographers Trust Fund and a Welsh Arts Council Travel Grant in 1987/8.

The map on page 9 was drawn by Lynwen Lewis, Y Lolfa.

The photographs of the Aberystwyth half-crowns on page 24 are reproduced with the kind permission of The National Museum of Wales, Cardiff.

The portrait of E A Mallet on page 28 and the Pengraig-ddu share certificate on page 30 are reproduced with the kind permission of the National Library of Wales, Aberystwyth.

INTRODUCTION

The Ordnance Survey map, Landranger 135 Aberystwyth, covers the whole area of the Cardiganshire mines. The British Geological Survey (Keyworth, Notts.) have produced a geological map of the Central Wales Mining Field which is very informative. However, the Ordnance Survey 1:25 000 First Series is recommended for walking in the field. Sheets SN 68, 69, 77, 78, and 79 are most useful.

The courses of the miners' leats, marked 1-3 on the map overleaf, make extremely interesting walks of varying lengths approximately 10 to 19 miles. But even short excursions along these ways, complimented with site visits, give a real sense of the mining landscape and provide a key to our industrial past.

The area is often very remote and extremely beautiful but—a word of warning—the sites themselves are potentially dangerous. Upstanding masonry, where it exists, is often unsafe. Shafts could be unfenced so don't go near the edges. Levels and adits are inviting but should not be entered without the proper caving equipment and an expert guide.

Strong shoes, waterproofs—it rains a lot here—your favourite sandwiches and a flask of tea (or something stronger) are the only equipment you will need but extras like binoculars to watch the Red Kites overhead, a geological hammer to extract your mineral specimens and a camera to record the event will weigh you down but are worth the extra effort.

For further information the following groups produce regular newsletters, magazines and books on the subject of mines and minerals in the U.K. They also organize field trips and meetings, rescue mines in danger of collapse, and lobby for the preservation and reclamation of these and many other wonderful sites of national importance. Join them today!

Association for Industrial Archaeology
The Wharfage, Ironbridge,
Telford, Shropshire, TF8 7AW.

Historical Metallurgy Society
Rock House, Bowen's Hill,
Coleford, Gloucestershire, GL16 8DH.

Northern Mine Research Society
41 Windsor Walk, South Anston,
Sheffield, S31 7EL.

UK Journal of Mines & Minerals
3 Oak Tree Road, Bawtry,
Nr. Doncaster, South Yorkshire, DN10 6LD.

Welsh Mines Society
20 Lutterburn Street, Ugborough,
Ivybridge, Devon, PL21 0NG.

Locating the Mines

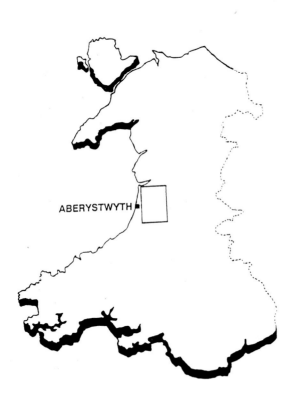

ABERYSTWYTH

Miners built reservoirs and miles and miles of leats—narrow channels to carry the water from the ponds (natural and artificial) and rivers to the mines to drive wheels and other machinery.

They are 3 feet wide and 2 feet deep, dug and lined with clay or hewn out of the hillside, sometimes of solid rock, laid over bogs and shorn with masonry. They were built to very slight gradients to limit the speed of flow and/or were regulated by sluices.

Network of Main Leats -○-

① Leat built by John Horridge, completed early 1840s. This leat carried the waters of the Leri from Craig-y-Pistyll to Cwmsebon; the overall fall was approx. 400 ft.

② Leat built by John Taylor and Sons, begun in 1850. This leat improved the loss of head of Horridge's leat and runs from Llety-Ifan-Hen to Cwmsymlog and Cwmerfin.

③ High Level Leat built by John Taylor and Sons ca. 1850. The supply of leat ② was helped by bringing the Rheidol tributaries into the Leri above Craig-y-Pistyll by means of a course from Esgair Hir via Camdwrbach.

Selected site photographs ▼

9

Mining and Metallurgical Techniques

Finding ore was always a curious mixture of chance, observation and superstition. The uprooting of a tree, a landslide or ploughing could reveal a valuable deposit. Metals were also associated with poor plant growth, with flowers paler in colour than normal and with dry earth 'if it be yellow, red, black or green or any other extraordinary colour'.

Less dependable methods of finding ore were reliance on dreams, watching for lines of fire, seeking the guidance of underground spirits or using a divining rod. It was believed that sulphurous fumes given off by ore showed themselves at night as lines of fire, and at least one Cardiganshire mine was discovered in this way. Underground spirits were also firmly believed in until as late as the end of the nineteenth century. These beings known to the miners as 'knockers', inhabited the 'Concaves and Hollows of the Earth' and were kind to 'Men of Suitable Tempers', leading them to new or lost veins by signalling underground with loud knocks.

Yet another method was the divining rod or wand, of hazel for silver, pitch pine for lead and tin, ash for copper and of iron and steel for gold. Another account claimed that the wand 'had to be a hazel cut before sunrise, especially the moon increasing and above all, about the day of the Annunciation of the Virgin Mary, it must be a yard long and of one spring's growth'. The divining rod was used regularly by the Germans in the lead/silver mines of Cardiganshire in the late sixteenth century. *(Fig 1.)*

Much early lead mining in Cardiganshire was carried out by the method known as 'hushing'. In this method a dam was constructed collecting water from a natural stream into a pond in the upper vicinity of an outcropping vein. This dam, when broken, allowed the water to rush down the hillside, washing and scouring a considerable amount of the loose ore body to a lower level. After the vein material had been collected, the

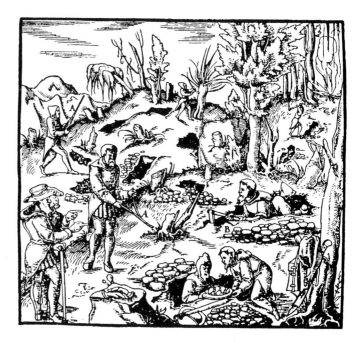

Fig.*1*. Prospecting and digging for minerals, *16th Century*

dam was repaired, water collected again and the operation repeated.

Early extraction was by means of digging a trench along a vein and following it down into the bowels of the earth, a practice known as the 'Roman' method of mining. It could be one hundred yards in length, twenty yards broad and forty or fifty yards deep. The digging was done with picks and mattocks after fire setting, *(Fig.2)* which was dangerous on account of the smoke-damp which filled the workings. Later it became illegal to light fires during 'mineral time', 8 a.m. to 4 p.m.

Prior to the sixteenth century there was a great dearth of practical knowledge in mining. One of the earliest illustrated

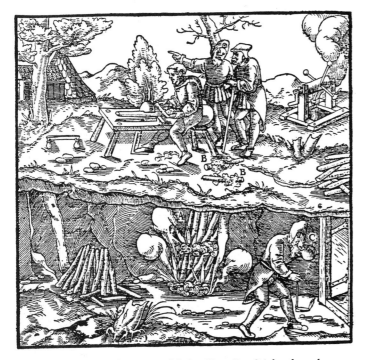

Fig.2. Fire-setting (after Agricola) A—Fire. B—Sticks shaved down for easy lighting. C—Level.

texts on the subject, 'De Re Metallica libri XII' was begun in 1553 by Georgius Agricola, 1494—1555, a doctor practising medicine in Joachimstal and Chemnitz in Saxony. His collected works have become the most valuable and comprehensive source of information on mining, metallurgy and mineralogy and detail all the technical advances made in Saxony during the period. The very same practises were adopted in Britain by the Germans employed by the Society of Mines Royal, and thus give insight into the mining techniques that were to prevail for several hundred years.

As the mine workings became deeper and shaft mining was adopted, the problems of drainage and ventilation became a vital consideration. Initially hand pumps and bellows were used to get fresh air into mine workings and simple bucket arrangements on chains were hoisted in and out by winch to raise the water out. *(Fig.3,6,7)*

Natural draining by the cutting of adits (tunnels for access and drainage) wherever possible was much preferred *(Fig.4,8)* and even by the end of the seventeenth century the Mine Adventurers only used pumps in exceptional circumstances.

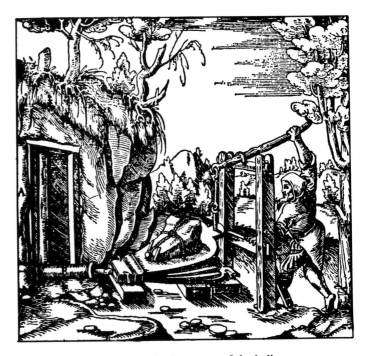

Fig.3. Ventilation of mines by direct use of the bellows. (Germany, *c*.1550).

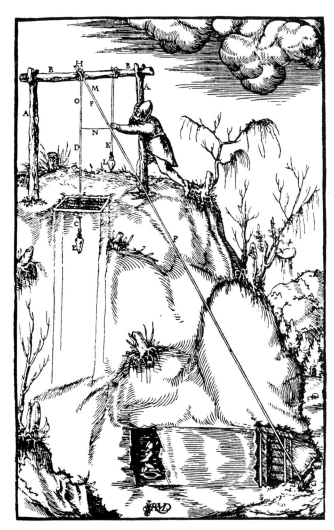

Fig.4. Driving an Adit or Level, *16th Century*

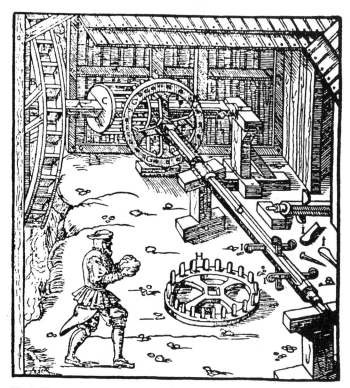

Fig.5. Water power as a motive force, *16th Century*

'Great care was given to the sorting and cleaning of the ores, whether by hand in trays and sieves or by washing, which latter method involved the construction of an elaborate system of wooden troughs, and channels so fixed and graded as to control the rate of flow, the natural streams and gradients in the immediate vicinity of the works being harnessed for the purpose.' *(Fig.5)*

13

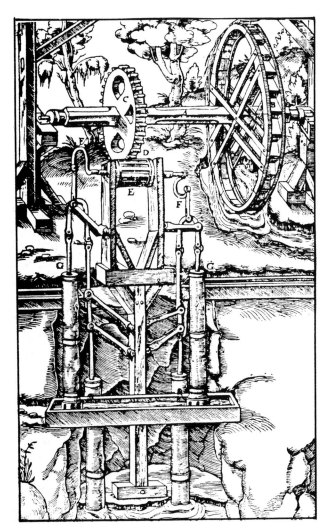

Fig.6. Drainage of mines. (Germany, *c*.1550). (*Agrigola*).

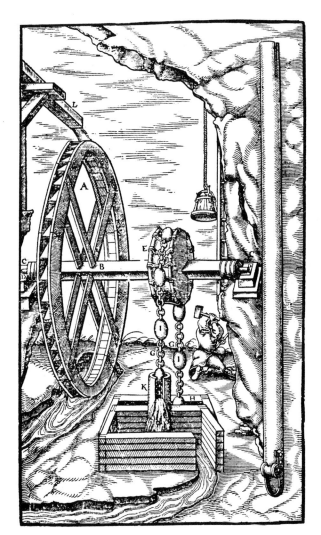

Fig.7. Water-driven *'paternoster'* pump (Agricola).

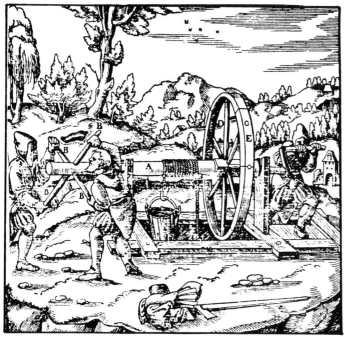

Fig.8. Hauling ore to the surface by means of winch. (Germany, c.1550).

After the removal of impurities by sorting and washing, the ore was taken to the stamp mill to be crushed into small pieces preparatory to being sifted, washed and roasted. Further impurites, such as sulphur and arsenic, could only be removed by 'roasting', so the ore was placed on closely packed firewood and literally roasted two or three times in the open. It was then crushed again and graded by washing and 'buddling'. The buddle was a circular device which, when fed with a constant stream of water, separated the ore from the slimes and wastes by gravity. (Fig.9,10,11)

The ore thus cleaned and dressed could then be smelted. In early smelting, alternate layers of ore and charcoal were placed in the furnace which was prepared with a layer of charcoal on the bottom, lime or iron added acted as a flux, a substance mixed with metal to facilitate fusion. The furnace was fired and the lead removed through a tap hole in the side. (Fig.12) The smelter was very skilled, and failure to observe the appropriate method could entail the loss of an entire smelting. The temperature was very important too, since casting at too high a temperature could result in the lead being brittle. It was generally maintained that the best lead came off first and contained the most silver.

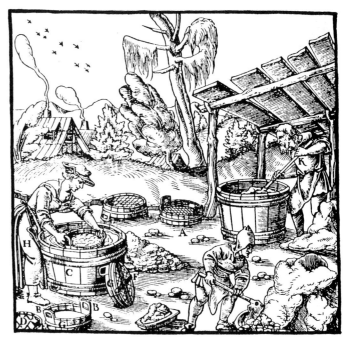

Fig.9. Ore washing, *16th Century*

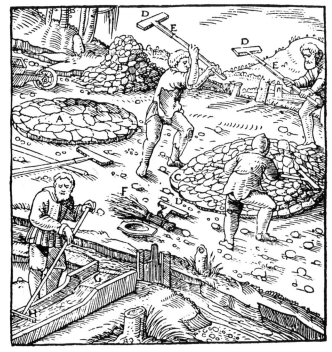

Fig.10. Breaking and washing ore, *16th Century*

The silver-bearing lead was then roasted again in another smaller furnace to refine the silver, a process known as cupellation. Bone-ash was used as the flux in this instance to 'fix or destroy the strength of sulphur before it operated on the silver, in as much as sulphur is destructive to silver'. Again skill and care were necessary to convert the lead to litharge, which was then removed from the surface by skimming or blowing, leaving the silver as a cake at the bottom of the furnace to be melted again and cast into ingots. *(Fig.13)*

All the preparatory work prior to smelting was carried out on site. Each individual mine had its own dressing floors, crusher houses, buddles and slime pits, laid out to make maximum use of the gradients and water supply.

In some of the larger mines techniques were gradually improved: crushing by hand gave way to wooden stamps, which in turn were superseded by roller crushers. In the small mines, of which there were many in Cardiganshire, these simpler methods continued to be employed throughout the various periods of mining with very little alteration.

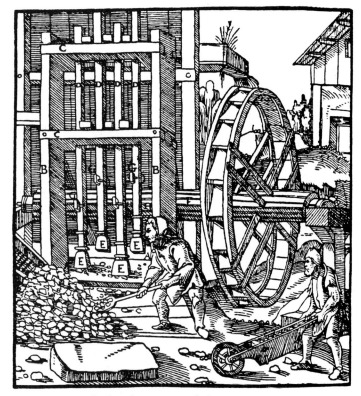

Fig.*11*. Stamps for breaking ore, *16th Century*

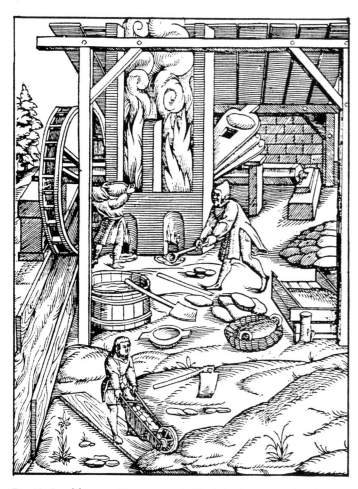

Fig.*12*. Smelthouse. (Germany, *c*.1550). Two furnaces, showing the bellows driven by grooved axle of waterwheel. Molten lead being ladled by Smelter from fore-hearth into moulds or cakes. Assistant re-charges furnace with ore and charcoal.

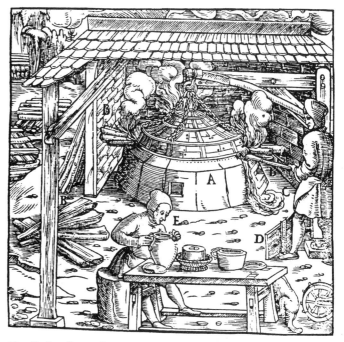

Fig.*13*. A refining furnace (after Agricola). A—furnace. B—firewood. C—litharge being drawn out of the furnace. D—protective plate. E—foreman eating butter to counteract the effect of the poisonous furnace fumes.

Perhaps surprisingly, given the abundance of water, hydro-electric power played no real part in mining in Cardiganshire. Electricity was only used at Frongoch in its last years and only one mine, Bwlch Glas, was powered by gas turbines. In fact, even steam engines were hardly used because of the high cost of transporting the coal necessary to fire them.

Attempts made to mechanise the Cardiganshire mines never met with great success, and mining and ore dressing methods tended to remain basic and primitive to the last.

Cardiganshire Lead and Silver

Between the River Dovey in the North, the River Ystwyth in the South, Cardigan Bay in the West and Plynlimon in the East, in one of the remotest parts of Wales lie the remains of what were the most important lead mines in Britain.

The mineral found here was special because it contained varying and sometimes large amounts of silver—argentiferous galena—and this is what attracted prospectors to distant Cardiganshire.

Silver was much sought after by Britain's conquerors, the Romans and the Normans, followed by her kings and queens who were always in great need of money and munitions for the wars they were continually waging. Later, in the 18th century early capitalists and entrepreneurs, in co-operation with the local landowners, manipulated mining operations from their offices in the City of London, the centre of the world's finance, where capital was more easily to be had than anywhere else on the globe!

Fortunes were made and lost in the booms and slumps of an industry that 'enriched a person or two in age but entailed the poverty of hundreds'. Even at its peak in the 1850's the miners themselves were only able to eke out the meagrest of existences. They were little better than slaves tied to the job, not by fetters and chains, but by an equally binding, ever deepening, debt to the company store.

Lead mining has been very widespread in Wales. There are workings in every one of the thirteen counties but by far the most productive and the most ancient of these mines are found in Cardiganshire. An important clue to pre-Roman working according to W. J. Lewis is suggested by the proximity of many of the mines to hill forts eg. Darren, (SN 679830) and Llwyn Gwyddel near Pen y Ffrwd-llwyd hill fort (SN 709688).

Recent excavations by the Early Mines Research group have prompted a re-think of history by dating several sites in Wales,

Wood dishes (or Bateas) used for measuring ore, *16th Century*

most notably, Cwmystwyth, Cardiganshire, and Great Orme, Gwynedd to between 1000 BC and 1800 BC, the Bronze Age. This ground breaking work has put an end to the fierce academic arguments that concluded no evidence for pre-Roman mining existed in Britain, by carbon dating charcoal remains of firewood from old spoil heaps on Copa Hill, Cwmystwyth.

Early miners used the 'fire setting' technique to break into the rock. Fires were lit against the rock and burned for hours. Then cold water was thrown over the hot rock to make it cool rapidly and crack. Stone hammers and antlers were used to pick out the loosened rock and the process begun again. The Early Mines Research group consisting of local archaeologists

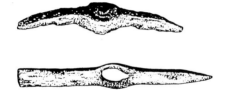

Roman iron pics for lead-mining. From Mendip, England. c.First century A.D. Scale1/7.

and mining engineers, felt instinctively that these stone hammers, found in quantity at many sites in Wales, were of ancient origin whereas rival scholars believed them to be of either Roman, Tudor or even Victorian date. It is easy to see how this conflict arose since mine sites were often worked at several times in history so that later activity often obscured the evidence of earlier occupation.

The Early Mines Research group has been proved right. Our Bronze-Age ancestors had the mining and metallurgical techniques to fashion the many bronze objects uncovered from this period and did not have to import either the copper

necessary to make them or the articles (axe heads, decorative body ornaments etc.) themselves.

Copper, lead in the form of galena, a lead sulphide which in its purest form contains eighty percent of the metal, and silver which is obtained from lead, are often found together and in many cases in Cardiganshire all three metals were mined and the minerals extracted simultaneously. Cardiganshire lead because of its very high silver content, was exploited by the Romans who were quick to occupy the areas where the ore was to be found. They worked many mines in Cardiganshire of which Cwmystwyth, Goginan, and Darren were the largest, and exported the lead to Rome where it roofed temples, lined baths and conveyed water. Their technology and an abundant supply of slave labour enabled them to extract the silver from the lead and this they coined to pay their armies and advance their conquests. The Romans were able to work largely by opencast methods since the mineral often outcropped at the surface as in the case of Darren. There they dug a great trench, fifty yards deep in places, right across the top of the hill, a feature which is still clearly visible today.

The Roman Occupation lasted from AD 43-410. When they left it seems they took their technology with them, for little is recorded until the next invasion by the Normans whose castle building and town expansion policies encouraged mining activities again.

Strata Florida—The Mining Monks

The Cistercians, a Norman monastic order (founded at Cîteau near Dijon in 1098) established the abbey of Strata Florida, Cardiganshire in 1164. They observed a stricter form of the Benedictine rule, 'work is the first condition of all growth in goodness'.

Stephen Williams, a nineteenth century railway engineer, became obsessed with the beauty of the site and its remains and determined to excavate it with the backing of the

13th century illuminated manuscript
prospecting for a 'stone which attracts
lead and resembles it'

Cambrian Archaeological Association.

In his 'Account of the Excavations of Strata Florida' published in 1889, he meticulously recorded his findings in particular the wide variety of decorated floor tiles unearthed from the ruins. He also observed a four inch diameter lead pipe which carried the water supply from an excellent spring, rising out of the rock, to the abbey itself. He goes on, 'there can be no doubt that the monks worked the lead-mines in the immediate vicinity of the abbey, as there was found in the present road-way near the river Teifi the bottom of a furnace where lead had been smelted; and in the fields surrounding the abbey are traces of other smelting places, and pieces of scoriae (slag) found scattered about in all directions. They also understood the art of extracting silver which is found (sometimes in very paying quantities) in the Cardiganshire lead ore'.

Elizabeth I: Minerals for the Crown

Until 1568 in English law, gold and silver were regarded as 'treasures from the earth' in the same light as treasure trove of coin, bullion, or plate and alone came to the king in his capacity of 'ultimate heir of the kingdom in common with all estates where no heir appears . . . waifs, strays, wrecks, waste land or land recovered from the sea . . . land of aliens dying before naturalisation . . . royal fishes and fowl'.

In 1568 Elizabeth I, in great need of money and munitions for war with Spain, established the Societies of Mines Royal and the Mineral and Battery Works. These were two joint-stock corporations whose duty it was to exploit the minerals of the whole country for the Crown. Elizabeth deemed a mine royal if the ore contained sufficient gold or silver to pay for the cost of refining and could be worked for the Crown regardless of whose land it was on. This was obviously very unpopular with the landowners who could see 'their fences broken down, spoil dumped on the land, roads made across it, streams diverted to drive the primitive pumps, and even tenants impressed to cart materials, or to labour at the flash of a royal warrant in some stranger's hand'. Landowners received no benefit from the proceeds of mining and no compensation whatsoever for land taken over by mining operations. The crown's right was absolute.

It is interesting to note that until the late sixteenth century the skills necessary to prospect for minerals, to mine and refine them and the expertise needed to produce armaments (battery, i.e. cannons, etc.) were all lacking in Britain.

The German Connection

Up to this point armaments had been imported from Europe, in particular Germany, and it was from this country that the men with the prerequisite skills were recruited by the Queen to the two societies of Mines Royal and Mineral and Battery Works to organise mining operations in Britain and pass on their techniques. Bringing them over was a very expensive business. They were accompanied by their families, provided with 'housing and hock' and settled initially in Keswick, where they were regarded with great hostility at first and had to be protected

by safe conducts.

The most influential of the German experts was Daniel Höchstetter, who represented the interests of Haug, Langnauer and Company of Augsburg, in Britain. Haug and Co. was a very wealthy business empire, international in its interests, which were mainly grocery, drapery and finance. They had just acquired some of the Fugger's holdings in metal mines in Hungary and Tirol and were seeking to expand this new side of the business. Elizabeth's invitation came at an opportune moment.

Three generations later Höchstetter's descendants were still taking a leading role in the British mining industry and the skills they taught remained virtually unchanged until its demise. Even the technological improvements of the industrial revolution, which made great progress in the refining process by the invention of the reverberatory furnace, did little to improve basic sixteenth century extractive methods in Cardiganshire.

Myddelton: the Mines Royal

The Society of Mines Royal achieved little in Cardiganshire until 1617 when Hugh Myddelton took over the society's leases. Myddelton, born into a prominent family in the parish of Hênllan; Denbigh in 1560 (?) was sent up to London to learn the trade of a goldsmith which at that time included banking. He became friendly with Sir Walter Raleigh and together they made profitable speculations on the Spanish Main. There is a tradition that Myddelton and Raleigh used to sit together at the door of the former's shop and smoke the newly introduced weed, tobacco, much to the amazement of passers-by.

Myddelton kept in touch with Denbigh troughout his life and in 1603 was elected MP for the borough, an office he held five times. He is best known as the man responsible for bringing London a new and much needed water supply in 1613. 'The New River' was a canal ten feet wide and four feet deep which

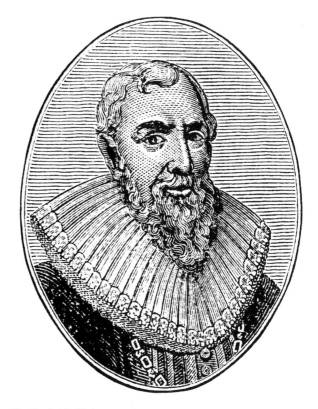

Sir Hugh Myddelton, 19th century woodcut after the portrait by Cornelius Johnson.

drew its supply from springs near Ware, thirty-nine miles to Islington, where, it discharched into a reservoir. This watercourse, with very little alteration, supplied London with water for nearly four hundred years. The New River was a masterpiece of engineering skill but a financial drain that Myddelton was to pay for with Cardiganshire silver. In 1617 James I awarded

him the leases of the mines-royal in Cardiganshire in recognition of his magnificent New River project.

Myddelton worked five mines as royal—Cwmsymlog, Cwmerfin, Darren, Goginan and Talybont. He found them ruinous and water-logged, but installed pumps driven by water wheels and thus was able to extend the workings several yards below the water-table. Myddelton had many difficulties; labour was scarce and unruly, the local landowners were hostile and machinery was often deliberately damaged or stolen. However, silver production began in 1620.

In 1623 James I ordered the metal to be coined weekly at the Tower mint and to bear the badge of the Prince of Wales (three ostrich plumes) on the reverse. This was the first time the symbol was used to denote the Principality. Implicit in the order was that Welsh silver should also be coined separately. This was not adhered to because Welsh silver was so pure, purer in fact than the Sterling standard, that if it was mixed with other less pure bullion, further refining was unnecessary.

The results of a refining trial of 1623 give an insight into the amount of silver present in the lead ores raised by Myddelton:-

3 tons of mixed ores smelted = 22 cwt. rich lead and 77 oz. silver per ton,
which when cupelled = 85½ oz. silver and 18 cwt. fine lead.

These numbers contrast with similar figures from the early twentieth century which denote lead bearing only 3 oz. of silver per ton as being cost effective to refine. They demonstrate the richness of the royal mines in this period.

Lead production also proved profitable. Lead had many uses. As well as forming roofs, pipes, gutters and glass windows, lead in sheet form protected the hulls of ships. Lead glazes were used in the pottery industry. Litharge (lead-oxide) a by-product of cupellation, was used in the making of casts with which to mend broken bones (the fore-runner of modern plaster casts). Myddelton's combined income from the two metals was estimated to be £10,000 a year. However, he had very substantial outgoings including overheads at the mines and the financing of yet another entrepreneurial scheme for the Crown, that of reclaiming land from the sea at the Eastern end of the Isle of Wight, which ate up the profits. Myddelton died in 1631 without having made a personal fortune and the royal leases passed to his wife, Elizabeth with whom he had sixteen children. In 1636, probably in need of money, Elizabeth was forced to sell the mine leases to the king's nominee, one Thomas Bushell Esq.

Bushell v The Rebellious Landowners

Bushell, an Englishman from Worcester, began his career at the age of fifteen as seal-bearer to Sir Francis Bacon. Bacon educated the bright and handsome young man and taught him, amongst more general lessons, 'many secrets in discovering and extracting metals'. Bushell was therefore well placed to take advantage of Charles I's offer of the leases of the mines-royal in Cardiganshire. He came to the king's attention by way of an unusual entertainment he devised at his estate near Woodstock and performed there for the King and Queen. The Royals were so taken with the masque and with Bushell's 'strangest and bewitching ways' that they rewarded him with the royal leases.

Bushell arrived in Cardiganshire in 1636 knowing very well that the local landowners opposed the working of the royal mines on their land. He attempted to placate them by offering the local squires, among them Sir Richard Pryse of Gogerddan, the opportunity to venture, at their own expense, and enjoy the profits, from opening any mine on their property. If they declined they were not to envy him if he proved successful. The wary Cardiganshire squires were not tempted. Bushell had tried and failed to secure the goodwill of the local gentry who resented the coming of an Englishman into their midst 'to

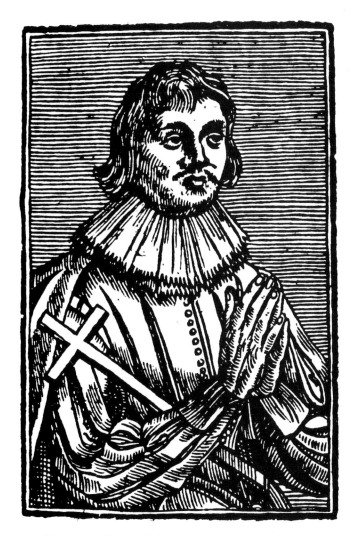

Thomas Bushel, aged about 30 (*Youths Errors*, 1628).

extract a fortune from under the land which had been theirs for generations'.

Sir Richard Pryse who was married to Hester, Hugh Myddeltons second daughter and owned 30,000 acres in North Cardiganshire, continually harassed Bushell with false claims, law-suits and physical assaults on his property. He carried on a personal vendetta with Bushell for over twenty years. The squires, Pryse and his neighbours did damage to the mines by pouring rubbish down shafts, they sabotaged machinery, prevented Bushell from getting a supply of turf and peat for smelting, stopped and diverted watercourses, drew miners away from their work (under false pretences) and ultimately took to highway robbery, stealing bullion shipments on their way to London.

Undeterred, Bushell set his men to drain the flooded mine workings neglected since Myddelton's death, and to repair pumps and shafts. Vandalism was suspected so that 'no incomer enjoyed the fruits of another's labour' but could not be proven. Bushell introduced the driving of adits (tunnels for access and drainage) a vital though enormous undertaking since the workings were getting deeper. The adits were eight feet high and four and a half feet wide, driven by hand and in one case more than six hundred fathoms long (one fathom = six feet). The driving was slow and costly. Bushell's men spent four years cutting adits at the expense of raising ore, but the mines thus drained, provided many rich veins from eighty to twenty-four ounces of silver per ton of lead smelted.

Bushell employed two hunderd and fifty men, but local labour was scarce, so miners from Derbyshire were impressed. (Royal lease-holders had the power to force people to work for them wherever they were required—forced re-location.) The Derbyshire miners settled in Cardiganshire and became smallholders squatting on common and waste land, supplementing their meagre mine pay with a little agriculture.

The New Mint at Aberystwyth Castle

Refined bullion had to be sent to London to be minted in the Tower, but before long Bushell petitioned the king to set up a mint in Aberystwyth on the grounds that it was expensive and dangerous to transport silver by packhorse to the capital (with bandits like Richard Pryse about!). There was a precedent involved, for provincial mints had been set up in the past at Durham and Bristol. Since monetary circulation was sluggish, Bushell's offer to set up a mint in Aberystwyth Castle at his own expence and to pay the workers out of his own pocket, was obviously attractive. The coins were to be distinguished by having the Prince of Wales' feathers on both sides. (On coins nominally of Welsh silver, the feathers had hitherto appeared only on the reverse.)

The Tower mint, a deeply entrenched monopoly, naturally viewed the proposals with great suspicion. But despite their opposition the king was won over by Bushell's 'strangest and bewitching way to draw in people (Yea, discreet and wary men) into his projects'. On 30th July, 1637, letters patent were granted. The first coins were struck in 1638 to mark the investiture of Charles as Prince of Wales and full production of the first Welsh coins began in 1639.

Bushell's expenditure at the mint must have far outweighed

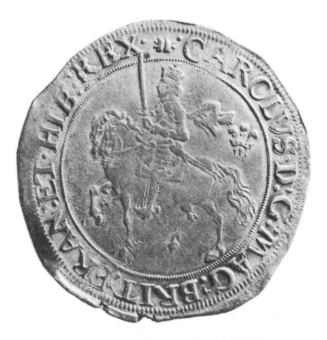

Aberystwyth half crown (front) *(NLW)*

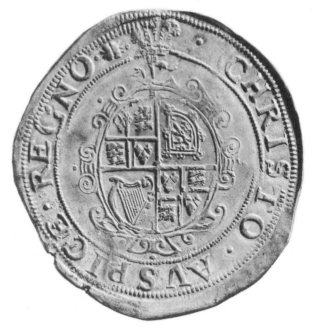

Aberystwyth half crown (back) *(NLW)*

profits (judging from the output of the mine 1639-42 = £10,000). He had to completely refurbish Aberystwyth Castle since it was 'utterly decayed': built in 1289, it had not had a penny spent on it since the accession of Henry VIII in 1509. Bushell was barely breaking even at the mines and Pryse was doing his best to ruin him by harassing and even stealing shipments. Bushell was mortgaged to the hilt. The mine at Cwmystwyth, which he was working for lead, was mortgaged and his wife's house also. Then, as if that was not enough, the English Civil War began to make itself felt in even this remote outpost of the kingdom.

The Loyal Bushell's Demise

By 1642 Bushell was deeply in debt. The Civil War was to ruin him completely. Although the struggle for power between the Royalists and Parliament was a war of religious and political ideas brought about by the king's attempts to impose, by force, reforms of Parliament itself, in order to get his own way, the war was to be won or lost by whoever had access to the most money. Immediately war was declared Parliament took control of the City of London containing the enormously rich Port of London and the Tower of London mint, leaving the King whose support lay mainly in the North and West of England, severely disadvantaged.

Charles I could not have had a more loyal supporter than Thomas Bushell. He raised a thousand miners from all over the country to fight for the King. He paid for uniforms for a further twenty thousand men including officers, a troop of horse and Prince Rupert's troop. He supplied 130 tons of lead shot and £100 pounds of silver a week to Shrewsbury mint. In 1642, at the King's command, Bushell moved Aberystwyth mint to Shrewsbury and as far as is known he never returned to Wales. Instead he took over the running of the Royalist mints at Oxford and Bristol, Charles I knowing very well that 'Moneys are the Nerves of War'.

Of course Bushell expected his loans and expenses to be reimbursed when the war was over. He had reckoned without the outcome, however, or the fate of the king who in the end lost the war for lack of money and was beheaded in Whitehall on 31st of January 1649.

'Our trusty and well beloved Thomas Bushell Esq. Warden of our mint, and Mr. Worker of our Mynes Royall' spent the rest of his life trying to recover his financial position. He was imprisoned for debt on several occasions and had to wait until the Restoration of the Monarchy in 1660 for even minor recognition of his services to the new king's father. This took the form of the Crown Appointment of the Customs on Lead, a paltry and not very lucrative position but one which gave him immunity to further imprisonment. Bushell died impoverished in 1674.

By 1646, when Aberystwyth fell to the Parliamentarians under Major General Rowland Laugharne, all working at the mines had ceased. The activities of the Society of Mines Royal were severely curtailed under the Commonwealth, and declined steadily in a post-war climate that was very unsympathetic to privilege and monopolies.

The Repeal of the Mines Royal Act—Early Capitalism Blossoms

By the late seventeenth century mining was becoming a highly specialized industry, sensitive to the reactions of the commodity market operating in Western Europe. Capital too was slowly becoming available, largely as a result of trade with the newly founded American colonies, and a new class of speculators, many of them landed gentry, was growing up to exploit the potentialities of their estates.

One such gentleman was Carberry Pryse (grandson of Sir Richard), upon whose land the mine of Esgair Hir was discovered. In 1691 Carberry Pryse disputed the rights of the Society of Mines Royal to this mine, thus attacking Crown

privilege. Surprisingly the Crown withdrew from the contest, and in 1693 the Mines Royal Act was passed, which relinquished Crown rights in mixed ores. This act 'quite altered the scene in the mineral world' by providing the impetus to landowners and speculators to prospect for and exploit mineral resources for their own profit alone.

In 1691 Carberry Pryse engaged William Waller, a mine agent, to manage the mines on his estate. They decided that they needed capital so in 1693 they created shares in the mines. Waller drew up a much exaggerated estimate of the profits the mines were going to make, comparing Esgair Hir with Potosi, a very rich silver mine in Bolivia, to encourage the shareholders to part with their money more readily—a ploy that unfortunately succeeded. Expectations generally far exceeded the realities of production and the continued practice of this deliberate dishonesty was to be as much responsible for the later decline of the industry as falling market prices.

After Carberry Pryse's death in 1694 Waller enlisted the services of Sir Humphrey Mackworth, an industrialist who, legend has it, he met in a local pub. Probably and more likely, Waller visited Mackworth in Neath. There the latter owned lead and copper smelting works, and the coal mines with which to power them. Waller was suitably impressed.

Mackworth's means were inconsiderable, according to the Dictionary of National Biography, until in 1686 he married Mary, the daughter of Sir Herbert Evans of Gnoll, Glamorganshire, who by the death of her four sisters had become the sole heiress of her father's property.

The Rise and Fall of the Company of Mine Adventurers

Mackworth needed regular supplies of ore to keep his furnaces going. He bought out Pryse's interest and the Company of Mine Adventurers was formed. The agent and new owner needed more capital so Waller simply repeated his 1693 estimates. In 1698 the company set to raise a further £125,000 by a very novel, though appropriate means—a lottery. Twenty-five thousand tickets were issued costing five pounds each. Ten per cent of them had the prize of a share attached. Of these shares, half gave the winner not only the possibility of a dividend should the company do well, but also the added bonus of voting rights. The other half were shares only—dividends but no voting rights. The remaining 90% of the £5 tickets were worthless.

The lottery aroused much criticism from those who didn't have winning tickets but was justified on economic grounds in that the money raised would 'provide work for the area, contribute to the relief of poverty and provide charitable institutions for the mining communities', a church and a free school. A charity school was built at Esgair Hir, and Waller was given £15 with which to pay the schoolmaster. However, only £5 of this reached the schoolmaster, the rest having to be made up by the miners who were charged 2s. 6d. by the company for each child attending. So much for a free school.

The lottery was quickly and fully subscribed to, Mackworth and Waller deciding how the money should be distributed. Large sums appear not to have passed through the books, for the moneys were disposed of 'without the render of an account' according to a Parliamentary Enquiry of 1910 into the Company's affairs. Thus was the Company of the Mine Adventurers of England launched, 'to bring under single management and for mutual advantage, through their common access to the sea, the orefield of North Cardiganshire with the coal resources of Neath' (William Waller 1698). The proximity of the mines to the ports of Aberdyfi and Aberystwyth was an important factor in their development and much exaggerated by Waller, who said that Esgair Hir was within a single mile of the sea when in fact it was over ten miles away.

In 1700 Mackworth took over the entire management from the new mine office at Angel Court, Snow Hill, in London. His Neath operation was enormous. By 1700 a copper house, a refining house, six furnaces for lead silver and a red lead mill were attached to the Melin Cryddan complex. Furnaces were

also constructed at Garreg on the Dyfi estuary, though these operated on a smaller scale. Waller estimated that the company was producing 80 oz. of silver a week which was sent to Isaac Newton, Master of the Mint, and coined again, bearing the Price of Wales' feathers on the reverse.

The 'Potosi' hype did not live up to expectations; Esgair Hir was a disaster because the rock there was extremely hard and the workings difficult to drain. The company acquired the leases to many other mines in the vicinity—Cwmystwyth, Ystumtuen, Goginan, Bryn Pica, and Pengraigddu among them and employed many hundreds of men, women and children. Men worked the mineralised veins (lodes) underground while women and children carried the ore out and crushed and dressed it by hand with hammers. There was, however, an acute shortage of labour to mine the ore. Miners were brought in from the North and 27 condemned criminals were offered hard labour and guaranteed a pardon if they worked in the mines for five years. 'When they had done (a day's work) they said they would better have been hanged than tied to that employment', Waller reported.

Sir Humphrey Mackworth, by this time, had become an extremely important and influential man, having been elected MP for Cardigan and Constable of Neath Castle. In 1704 the business was a prosperous concern, but greed seems to have got the better of Mackworth and Waller and by 1706 the company was described as a 'labyrinth of fraud, bolstered by paper finance, unable to meet its commitments to either creditors or shareholders' (Parliamentary Inquiry 1710). Reductions were made in the staff in London, and in Wales and Waller was sacked, being made the scapegoat of the company's mismanagement. He was accused of misappropiating money and fraudulent activity at the Garreg smeltmills, both of which he was undoubtedly guilty. Equally to blame, however, was Mackworth, whose methods of raising money were indisputably deceitful. In 1710 a parliamentary inquiry held into the company's activities resolved, unanimously, that 'Sir Humphrey Mackworth was guilty of many notorious and scandalous frauds and indirect practices'. Mackworth was discredited, but only temporarily as there was, in the same year, a fortuitous change in the government. The new parliament took no further action against him and, Sir Humphrey unscathed, was able to build up his Neath venture again, this time with coal.

The Fever of Speculation Hits the Mines

These events did not put an end to the activities of the Company of Mine Adventurers, but there was little spirit left in them after 1710. In general the whole of the industry was in a depressed state as a result of the lack of confidence in the City after the South Sea Bubble affair. The origins of this fiasco were laid in 1711, when The South Sea Company was formed to trade with Spanish America. In 1720 it assumed responsibility for the national debt in return for a guaranteed profit. A fever of speculation—the South Sea Bubble—set in and shortly afterwards the company failed. Thousands of investors lost everything.

This joint-stock system of financing severely hampered the development of mining operations in Cardiganshire. The money needed to exploit a mine came from shareholders, or adventurers, as they were known, who were only interested in profits. There was no money for vital exploratory work when a mine's reserves were getting low, no money for research and development. No money in reserve to keep a mine working when prices slumped. Consequently, a great deal of open-cast mining was undertaken, cheaper, easier and requiring a lot less skill. Deliberate damage was often done to a mine to effect a reduction in the terms of the lease. Often, mine captains would set about extracting every particle of ore regardless of the future prospects of the mine. A robber economy flourished. By the end of the 18th century many of the mines were in a very poor state, the work in them being described as 'fitter for hor-

ses than men'.

Wild fluctuations in the price of lead also had a bad effect on work at the mines. The steady fall in prices in the 1780's, combined with the outbreak of the Napoleonic Wars in Europe in 1793, affected the entire commodity market causing another great slump. The result was a marked decrease in the number of mines worked and a reluctance to develop promising new works. Big fluctuations in the price of ore could only be borne by the more prosperous larger concerns who were only interested in quick returns and easy profits.

Greedy Landowners

Some of the many out of work miners took out 'tack notes' on the Gogerddan Estate and others were given permission to re-work waste dumps because the methods of ore dressing were still very inefficient and much good ore was to be found in the waste. These agreements were very expensive for the miner, the taker, who not only had to bear the cost of essential items such as candles and gunpowder himself but also had to sell his dressed ore to the landlord at half the market price.

The landlords, owners of the mineral rights, had a reputation in Cardiganshire, for demanding ludicrous royalties out of all proportion to the value of the concentrates, sometimes as high as one seventh. A percentage of every ton of ore raised from the ground (since 1693) had to be paid to the Pryses of Gogerddan, the Powells of Nanteos or the Lords Lisburne. This made them the most consistant beneficiaries of the considerable profits that were made out of the mines over a period of two hundred years.

The Cornish Engineer

The final period of prosperity came between 1830 and 1890. In 1834 John Taylor took over the management of the Lisburne mines, centred on Frongoch (SN 723745). Taylor had worked

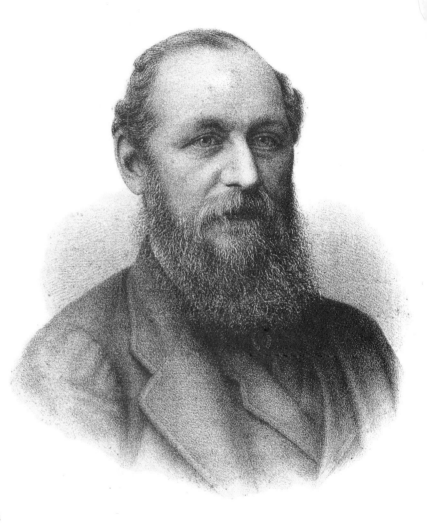

Ernest Augustus Mallet, Fifth Earl of Lisburne. *(NLW)*

in all the major orefields of Britain and Ireland where he proved himself to be an able administrator as well as a scientist. He contributed to many scientific journals on subjects such as smelting, blasting, ventilation and steam engines. His services, and those of his company, John Taylor and Sons, were in great demand because he had earned a reputation for taking into account the long term prospects of a mine as well as satisfying the shareholders' lusts for short term profits, in stark contrast to the majority of operators the boom attracted.

John Taylor, a Cornishman, came to Wales in 1822 at the request of the Duke of Westminster who had large holdings in Flintshire, most notably Halkyn Mine. The Duke wanted Taylor to 'rationalize' Halkyn; re-organize the mine on scientific lines, eliminate 'waste of labour, time, materials and effect a reduction in overall costs'. It was Taylor's policy to explore a mine properly, determine its potential and only then to prepare the ground and install equipment and machinery.

Initially Taylor was hampered by a fall in prices from £27 per ton in 1825 to £20 per ton in 1828. The native Welsh miners resented the Englishman and blamed him for the slump. Many rejected the changes Taylor was introducing. But after these early difficulties, even riots and strikes, Taylors policies of improvement succeeded. Others before him had looked no further than to reduce miners' wages to increase profits. John Taylor's employees could be sure of their wages every month unlike those in eight out of ten mines in the district.

The success at Halkyn resulted in John Taylor being offered the opportunity to do the same for Lord Lisburne at his mines in Cardiganshire, the largest of which was Frongoch. The same success was achieved. Taylor built new reservoirs, new roads, and barracks for his miners. Lisburne mines worked continuously from 1834 to 1893. Frongoch produced 107,174 tons of lead ore, and 50,000 tons blende (zinc ore)—total value £1,338,793.

In 1851, 343 Cornishmen were living in the mining area of Cardiganshire, brought in by Taylor. Miners from Yorkshire

John Taylor 1779-1863 (British Museum)

and North Wales were also resident during the boom, swelling the small local population.

Pryse and Powell (Nanteos) jealous of Lisburne's success, which amounted to £2,000 a year in royalties, also hired John Taylor. But their results were not so impressive. More capital had to be spent at Esgair Hir because bad practices had ruined the mine. But Goginan produced 193 tons of ore per month in 1842-3, resulting in fat profits for Pryse.

A 'Free For All'

Taylor's success attracted many speculators from all walks of life. Men with little or no mining experience and no knowledge of the field tried their luck in Cardiganshire. Many dishonest tricksters, who had little interest in actually working a mine found a much easier way to make money. A poor mine purchased for a few hundred pounds could be resold for many thousands as a 'good prospect' to shareholders in the City. The mine could be declared bust shortly afterwards and then be put on the market again under a new name. A mine could be sold several times over this way because Cardiganshire was so remote from London it was difficult to check the accuracy of company reports.

Overcapitalisation meant that thousands of pounds could be spent on the surface features of a mine, crusher house, buddles, slime pits, tramways, offices etc. without a mine first being explored (see Bryndyfi). There would be no money left to work the mine if the ore body did not live up to expectations. But as far as the shady speculators were concerned, if the surface buildings gave a good impression, then they could sell the mine no matter what lay underground. In 1885 a correspondent in the Mining Journal estimated that since 1840 it was doubtful if one tenth of the money raised had been used in actual mining operations.

In 1870 John Taylor wondered at the so-called experts who made definite statements about the prospects of mines 'when no more was known now than in the past about the means of ascertaining the true value of a mine . . . If a manager were honest he would visit the mine several times a week and report honestly on the work. If he were not he would sit down and write a glowing report in response to a gentle hint from the company secretary that, unless there was a good report the shareholders would lose heart' and the managers their jobs. Eventually, Cardiganshire got a bad name for corruption and fraud and by the 1880s the last decline was well underway.

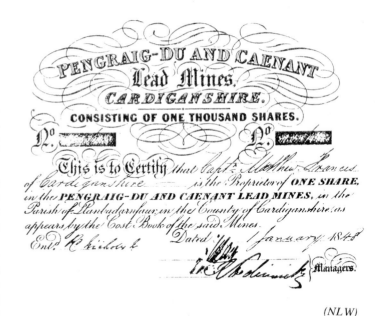

(NLW)

Conditions of Labour

Life is a place
Where we dig in a hole
To earn enough money
To buy enough bread
To get enough strength
To dig in a hole

Ancient Miner's Lament

North Cardiganshire is rugged and almost entirely rural. Deep, steep river valleys run East to West, some of the high moorland tops now dominated by modern blanket afforestation, their sides dotted with grazing sheep. The valley floors contain fast picturesque rivers rushing through narrow flood plains, and deep gorges like Devil's Bridge in the heart of mining country, which has attracted a multitude of visitors for centuries. Since the 'Grand Tours' of the 18th century when adventurous travellers, novelists, scholars and just plain curious gentlefolk made long and arduous journeys around the beauty spots of Britain, Devil's Bridge has been on the tourist trail and so, too, have the mines. Wales was 'discovered' by many visitors who recorded their observations in journals, over fifty of which were published between 1770 and 1800.

In 1775 sightseers could hire postchaises in Aberystwyth. So popular was this form of transport that the 'Cambrian Tourist a post-chaise companion', was published to assist travellers in the planning of their itinerary. Roads however were few and far between. Most were rough, unmetaled tracks which in this area of Cardiganshire were forged by the ore-carriers—their carts and pack-horses—which bore the ore to the port of Aberystwyth from whence it was shipped to Neath and Swansea for smelting.

One young Englishman, Benjamin Heath Malkin made extensive tours in Cardiganshire in 1803. He was educated at Cambridge where he gained an MA in 1802. After graduation,

as was then the fashion, he embarked on his 'Grand Tour' before settling into his first job as a headmaster. Because of the Napoleonic Wars in Europe it was unsafe to travel to the traditional countries for the 'Grand Tour', Italy and Greece, so Malkin and many others had to make do with more modest tours of the British Isles. Malkin's findings are recorded in 'The Scenery, Antiquities and Biography of Wales from Materials collected during two Excursions in the year 1803'.

He visited not only the 'giddy precipices and stupendous dingles' of Devil's Bridge but went a further five miles into the Ystwyth valley, where he came upon the most visible aspect of the lead mines to be seen at that time, and which to this day remain very little changed—the great Cwmystwyth Mine.

The Cwmystwyth works extended for a mile in an easterly direction just outside the village and occupied the whole of the north side of the valley. Malkin did not like what he saw. 'The dingy and unsightly piles of dros and sifted refuse, with the squalid garb and savage manners of the male and female miners are beyond belief', he wrote. But he had to admit that 'the whole of this rugged region is one immense reservoir of metallic treasure'. And so it was. Until its demise in 1923 Cwmystwyth was one of the richest and most consistently worked mines in the county.

In 1880, 173 men, women and boys were employed at the mine, 112 underground and 61 at the surface, raising, crushing and washing hundreds of tons of ore. To this extent Cwmystwyth was untypical of the Cardiganshire mines which were in the main very much smaller, employing only a handful of men and measuring output in tens of tons rather than hundreds. At the industry's peak around 1850 approximately 250 small and medium-sized mines produced 10,000 tons of lead which was more than anywhere else in the country, at a time when Britain was the world's leading producer.

The work was laborious and dangerous. 'Frequent injuries happen to him in blasting the rock, and digging the ore, and cold, damp and vapour unite in destroying his health and short-

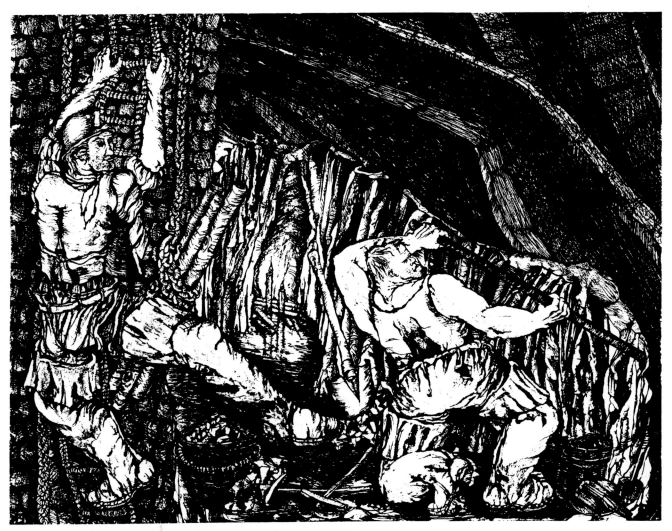

Miners underground in the 18th century

ening his life,' wrote the Reverend Richard Warner on a walking tour in 1797. In the vicinity of Cwmystwyth Warner met a one armed angler. 'Despite that apparent disadvantage and using the left hand only, he managed a line of uncommon length. On addressing some enquiries to him we found he'd formerly been engaged in a lead mine, but having had his right arm crushed when blasting a rock, he was obliged to relinquish that employment and had now recourse to fishing, for the support of himself and his family.'

Many miners lost their lives in falls from the long ladders they used to get in and out of the vertical shafts that gave access to the mine workings. The introduction of gunpowder to Wales in 1694 led to a great many more accidents, and many men lost limbs or eyes. However, lead mines were infinitely safer places to work than the coal mines of the period; workings that suffered from frequent explosions of fire-damp. Happily this phenomenon was extremely rare in Cardiganshire, 'the slates there being no apparent cause in such cases for that spontaneous generation of inflammable gases productive of such terrible and fatal effects'.

Poor ventilation and the inhalations of silica-laden dust, aggravated by working constantly in very wet conditions underground, led to chronic lung diseases among miners, making them vulnerable to tubercular conditions. Not surprisingly their life expectancy was very low. A lead miner was literally worn out by the time he was forty.

Home offered little respite for the miner, for whether he lived in a tiny cottage or the mine barracks, conditions were very bad. 'Habitations are poor, very confined, overcrowded and poorly ventilated. A cottage might be 16' x 12' of one room, possibly two, with a linen partition, having one small fixed window that could not be opened and an earth floor'. The tubercular miner slept in the same room as his wife and childern. His diet was bread, butter and tea, with possibly a little meat on Sunday. Not surprisingly 'most of the people of this county get a very sallow look', reported a witness to the Kinnaird Enquiry, a government investigation into the health and safety of the mines in 1864.

Miners, however, did not have a monopoly on poverty, widespread and general in Cardiganshire at the time. Catherine Sinclair, novelist, philanthropist and tourist, records on her tour in 1833; 'In every direction along the Welsh roads we were surrounded by poor people setting traps for money and wishing to sell specimens of lead and copper ore. No omnibus could have been found capable of carrying all that travellers are expected to purchase during a progress through Wales.'

Miners' wages were low and irregularly paid, making it necessary for whole families to be employed as an economic unit. While men dug and raised ore to the surface, women and children carried the ore out and washed and dressed it for market. The average wage for a family of four in 1699 was 14s. By 1877 this pay had only risen to 20s. and was totally inadequate for the family's needs. Most miners were also smallholders, so were able to supplement their mine pay by growing some of their own food whilst the local farmers also gained employment at the mines carting ore to the ports of Aberystwyth and Aberdyfi. The money they earned was vital in enabling them to pay their rents and stay on the land.

Another method of payment was the 'bargain'—a form of piecework whereby the miner agreed in advance to raise ore for a certain price per ton from a particular section of the mine depending on the degree of difficulty involved and hardness of the rock. He was paid subsistance wages until the bargain was achieved and because of this would often get into debt at the 'truck' shop where he had to buy his own mine supplies such as candles, drill bits and gunpowder as well as basic food supplies for himself and his family. Truck came about to supply the needs of miners compelled to live and work in remote areas where it was not possible to purchase these necessities. Unfortunately it became a much abused practice, the mine companies or their agents charging very inflated prices for their goods because they were not to be had elsewhere.

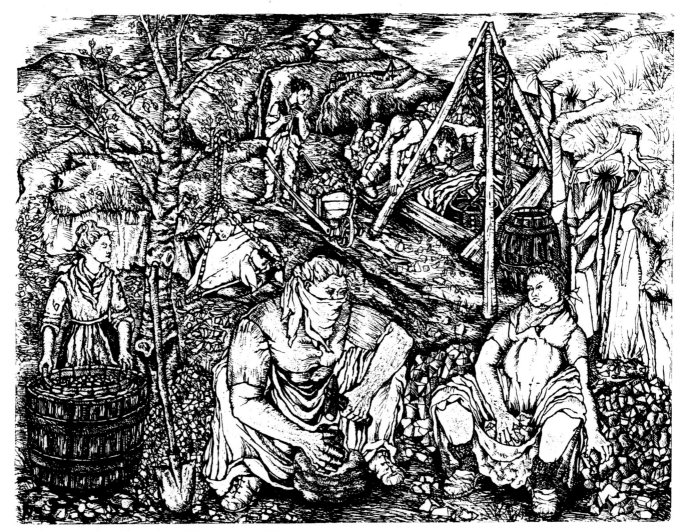

Women sorting, breaking and washing ore in the 18th century

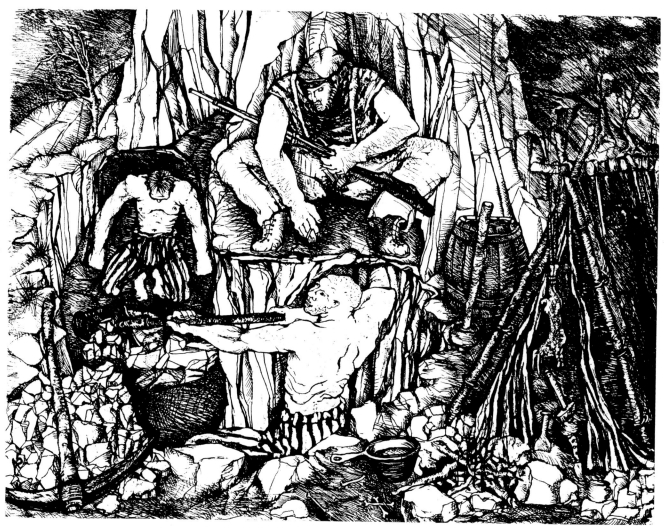

Convict labour in the 18th century

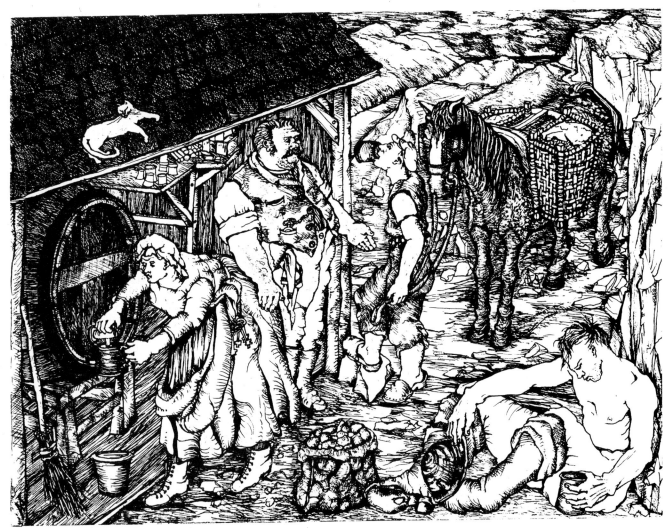

Truck shop in the 18th century

The worst abuser of the truck system was John Ball, mine agent of the Company of Mine Adventurers who in the 1750's was 'growing fat as the workmen grew lean'. As well as his shops of miners' necessaries 'he opened up ale houses and a brandy shop on site, converted an ore-washing tub into a vat for brewing beer and, when the weather was bad, would only allow the miners to shelter in these places if they bought between them a large bowl of punch at 2s6d or a 'brown cow' which contained seven to nine quarts of ale'. In order to get a good bargain with Ball they had to drink large quantities of ale and spirits or simply bribe him.

Small wonder then that skilled labour was hard to come by in Cardiganshire. Miners would hardly have been attracted by the wages and conditions. The 'hard rock men' were a rare breed.

All the holders of royal leases had power to direct miners to Cardiganshire from other mining areas such as Derbyshire, Cornwall and Italy because there was never enough skilled labour to be had locally. These miners settled in Wales bringing their language, culture and religion with them. A Wesleyan circuit was established in the mining communities of Goginan, Cwmsymlog, Ystumtuen and Cwmystwyth. Two Roman Catholic Churches were built in the vicinity of Frongoch and flourished for a time but both faiths were short-lived and as the industry declined for the last time in the 1880s, these communities suffered. The miners left to seek employment in the coal mines of South Wales and the villages declined almost to the point of extinction.

Two natural phenomena boosted the mine adventurers' undertakings in the county. Firstly, mineralisation, initially at least, was relatively shallow, enabling the mines to be worked by opencut and drift methods. Secondly there was and is a great abundance of water. Amazingly the only source of power used in the mines until the last quarter of the 19th century was water harnessed by gigantic water wheels, some as large as 50' in diameter. These in turn operated water pumps used to extract water that collected in the deeper workings, air pumps to ventilate the shafts and adits and winding gear.

Lead ore was processed at the mine, so water wheels were employed to power the stamps that crushed the ore to a manageable size. Water was also essential to all the ore dressing-processes of washing and separating, so great efforts had to be made to keep the mines adequately supplied.

The miners built reservoirs and miles and miles of leats (narrow channels lined with clay and constructed on very slight gradients) to carry water from the ponds and rivers to the mines. The best example is Taylor's Leat, 19 miles long, which supplied 10 mines and turned 50 wheels. It is still easily traced on the slopes of Fainc Fawr.

Leats and mine tracks are predominant features of the present landscape which have lasted to reflect the centuries of working and re-working that have modified the countryside. These mine tracks had to be hewn out of hillsides, sometimes of solid rock and were no mean feats of engineering. Opencast trenches were often filled in again after mining had ceased because of a widely held belief that ore was a living substance which would grow again.

The mining landscape, in its heyday, when ariel ropeways, tramways and huge water-wheels were operating, must have been a sight to see. Little remains of these features above ground and centuries of neglect have contributed to a peculiar naturalism that pervades the many spoil heaps and tumble-down masonary.

However, because of their inaccessibility, the underground workings are much less damaged by the passage of time. Cwmystwyth alone has 84 recorded adits and levels, many now collapsed and filled in but a few, like the great Level Fawr, can still be entered. The only barriers between the world outside and this 2 mile head high, underground tunnel are a loose, rusty iron gate and 30 yards of icy, knee-deep water. Once inside the rough, dark grey walls are alive with minerals, green malachite, black manganese, copper and calcite crystals. The tunnel leads to the huge caverns formed as the metal was

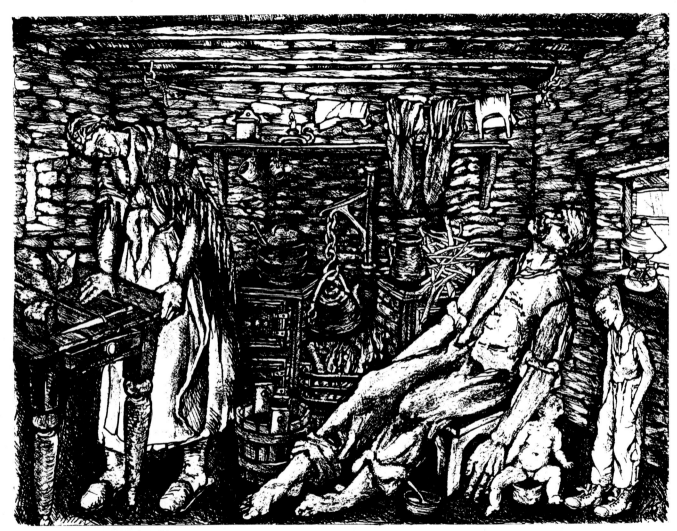

Miners cottage in the early 19th century

stripped out by the miners. These so-called stopes, the largest of which is 40' wide x 100' high, still contain features and equipment that give the overwhelming impression that the miners have just gone off shift and will be back in the morning. The only inhabitants of the labyrynth now are several species of bat and the ghosts of the old hard rock men.

Looking at all that remains, it is possible to appreciate and admire the great skill and knowledge that was necessary to make the lead mines work. These are work places that functioned, had moving parts and were all part of a thriving industry that was once of very great importance.

THE PHOTOGRAPHS

ESGAIR MWYN SN 755 692
Dressing Plant and Spoil; View of Glog Fawr

In 1947 this processing plant was installed to rework the large waste dumps for lead and zinc. It contains all its machinery which is still operational. The mine is now owned by an engineer who dreams of re-opening it.

Esgair Mwyn is most famous for bringing to a head the opposition of Welsh land owners to the Crown's claim on wastes and unenclosed land in the 1750s.

Esgair Mwyn had been rediscovered by Lewis Morris who in 1752 was appointed Agent and Superintendent of his Majesty's Mines in Cardiganshire and Merioneth. His most active enemies were Lord Lisburne, T. Powell of Nanteos, C. Waller and J. Ball, the local agent for the Company of Mine Adventurers, who sought to establish a claim to the mine of Esgair Mwyn by persuading a poor freeholder to grant them a lease of land adjoining the mine. The case ended in a compromise, the king kept the land and the mine, but did not prosecute the ring-leaders of the opposition. In 1788 Lewis Morris lost his post because of discrepancies in the Esgair Mwyn accounts.

In 1788, Esgair Mwyn ore was sold at £12 per ton, miners worked in groups of 4, 6, and 8, were paid 10d. for a 12 hour day and women were employed as carriers.

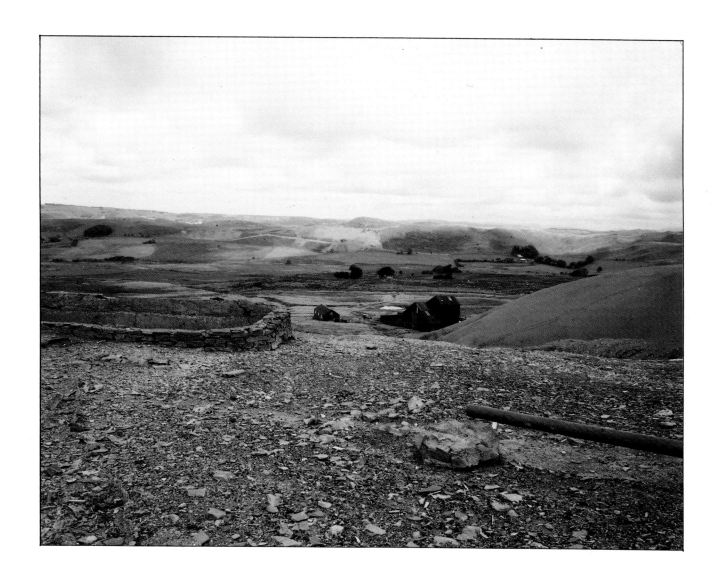

GLOG FACH SN 747 706
Shaft with Dead Sheep

The consequences of illegal dumping of livestock and household rubbish down
shafts are grave.
Decay and erosion combined produce seepage which finds its way through
the underground mine workings into the water courses and drinking water
supply.

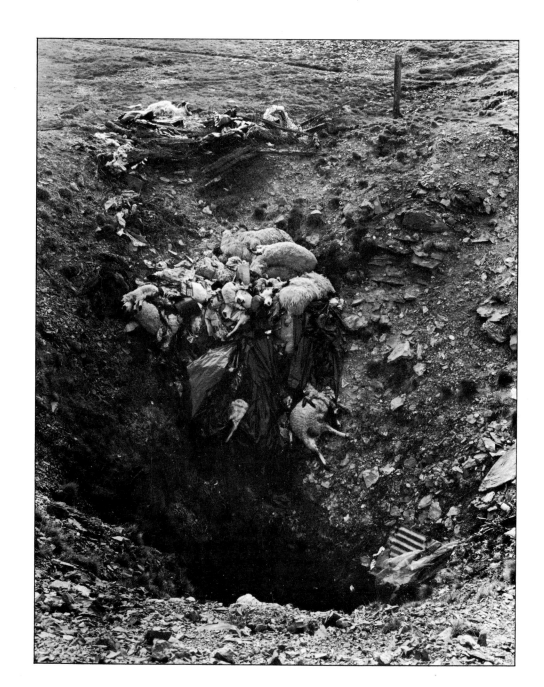

GWAITHGOCH SN 708 721
Crusherhouse and Bridge Piers

This crushing and dressing mill was constructed during the first World War to process the huge Frongoch waste dumps for lead and zinc. It was financed by the government and linked with Frongoch by an aerial ropeway two miles long. It was operational until the late 1920s. Access to the site was by a causeway over the River Ystwyth indicated by the bridge piers extant in the foreground of the photograph.

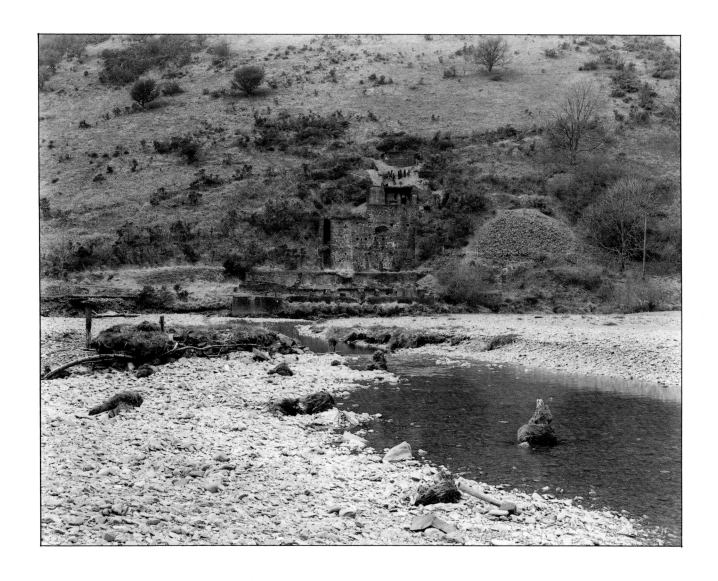

GRAIGGOCH SN 703 740
Engine Shaft circa 1840

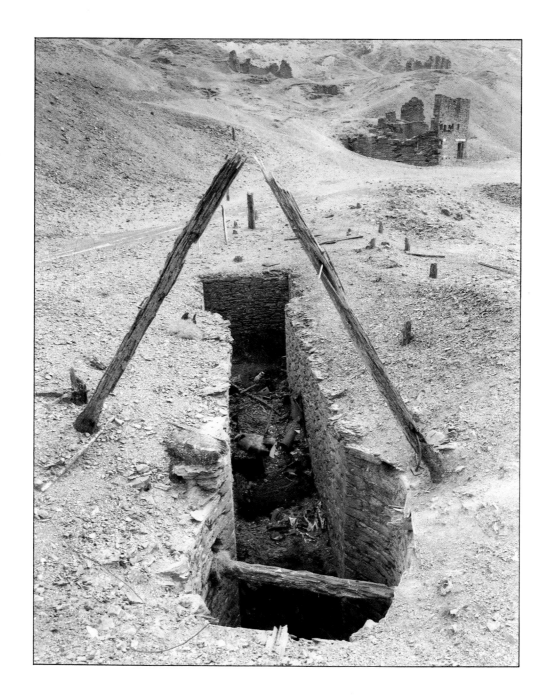

FRONGOCH SN 723 745
Site looking NE with 60 inch Cornish Engine House and Bikers

This mine was the most productive in Cardiganshire.
The most spectacular building on site when this photograph was taken, was
the pumping engine house with a stone and brick chimney stalk. It was built in
ca. 1870 to house a Cornish beam engine. However, sadly the chimney stalk
collapsed in the 1990 gales. The Lisburne Development Syndicate formed in
1907 was involved in removing and treating the enormous waste dumps for lead
and zinc when the demand for metals rose during WW 1. This sort of activity
continued until 1929.
In 1991, Lord Lisburne, director of Frongoch Resources Ltd. applied for
planning permission to turn this site into a land fill rubbish dump for domestic
and industrial waste despite local opposition to the proposals.

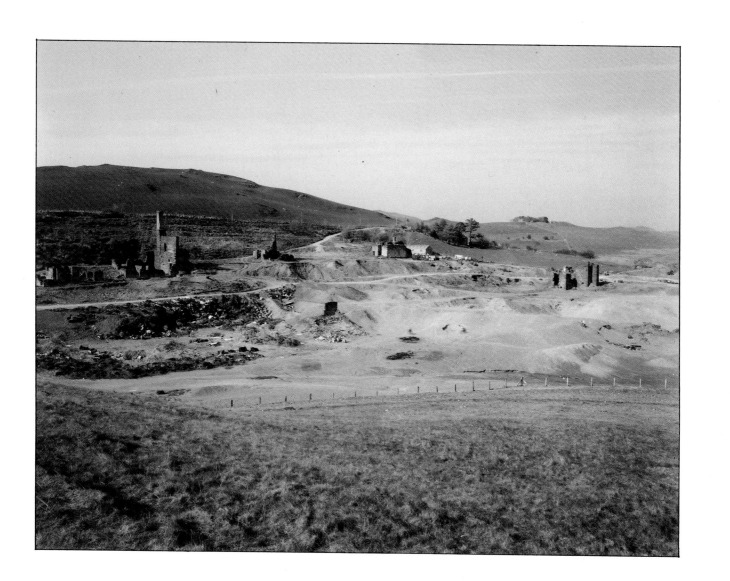

Frongoch electrical circuit, 1901 (E.H. Davies)

FRONGOCH SN 707 744
Powerstation, 1901

This hydro-electric powerstation, built in 1898 by a Belgian company, the
Societé Anonyme Minière, generated electricity for Frongoch. It was driven by
water collected and supplied by three reservoirs situated high above the station.
In times of drought a steam engine was put into action.

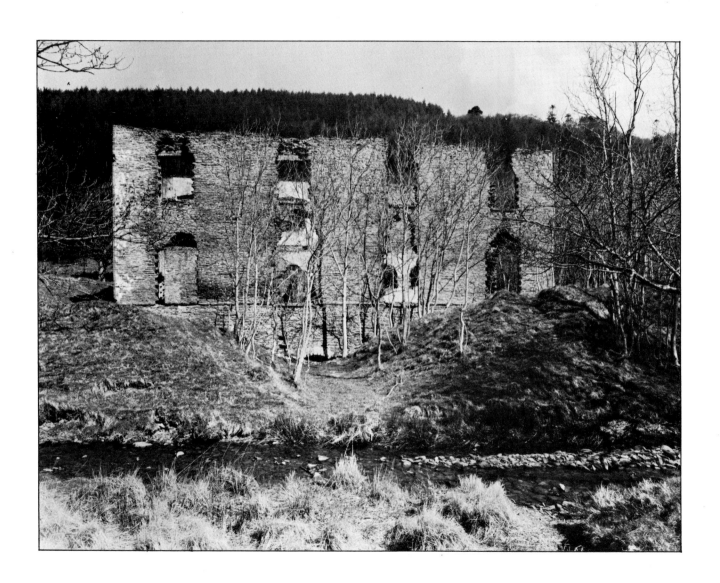

CWMYSTWYTH SN 803 746
Lead and Blende Dressing Complex of Pugh's Mine

The main building (centre), the water-powered concentration mill, was erected in 1899 on the site of an earlier mill dating from the 1870's. To the left of the mill are the remains of the office block, to the rear, a compressor house that could supply power to the mill by means of a wire rope in periods of drought; and to the right the No. 2 crusher couse, of earlier construction, the wheelpit of which is clearly visible.

The mill could dress 10 tons of ore per hour and required eight men and three boys to operate it with an additional ten boys sorting ore by hand at 'picking tables'.

Since this photograph was taken the concentration mill has been demolished because it became unsafe.

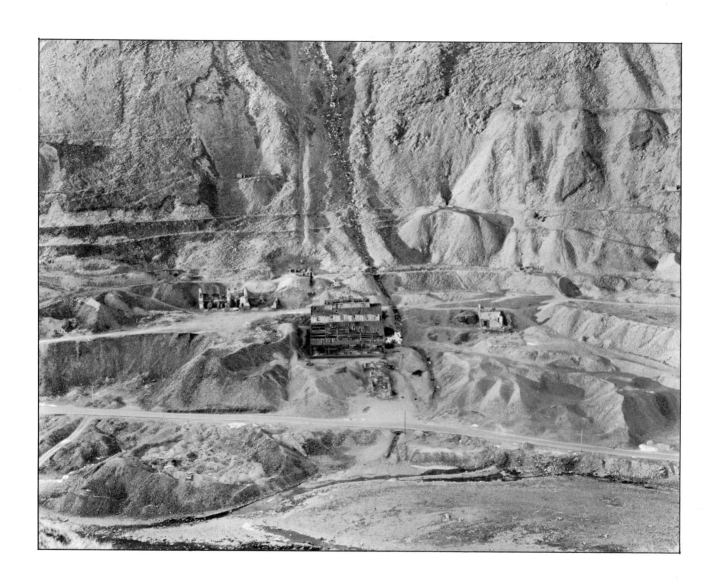

CAEGYNON SN 718 784
Mine Buildings with Old Adits and Dumps

This mine is an old work which was re-developed in the 1850's by Absalom Francis, who had an engine shaft sunk (shaft with pumping equipment) 100 feet above the road.
This mine was intermittantly worked until 1912.

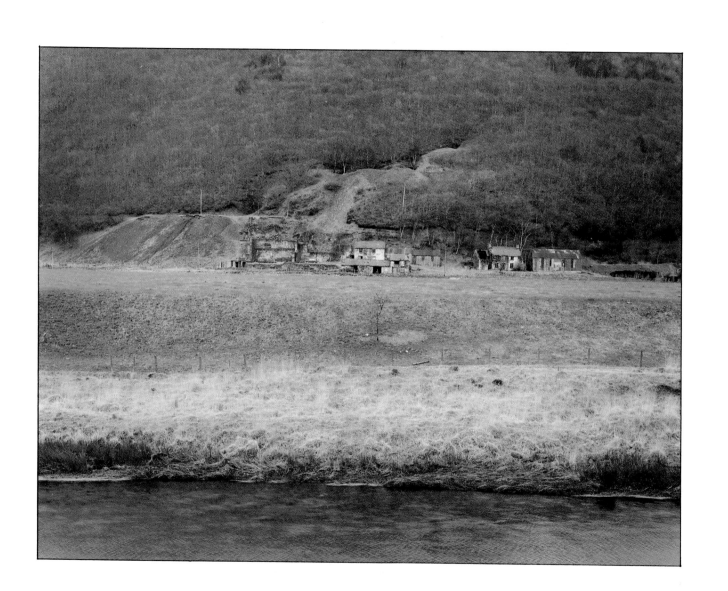

CWM RHEIDOL SN 730 783
CEGB Water Filtration Plant

Old mine workings are a major source of water pollution. They pose constant
problems for the authorities who are not meeting their obligations to prevent
contaminated mine seepage reaching the drinking water supply.
This CEGB water filtration plant receives drainage from the old mine levels
of Cwm Rheidol and Tynfron and discharges directly into the River Rheidol.
The plant is badly maintained and represents a poor attempt to deal with one of
the few visible symptoms (Iron Oxide) of a very much larger insidious pollution
problem indigenous to the whole Cardiganshire minefield.

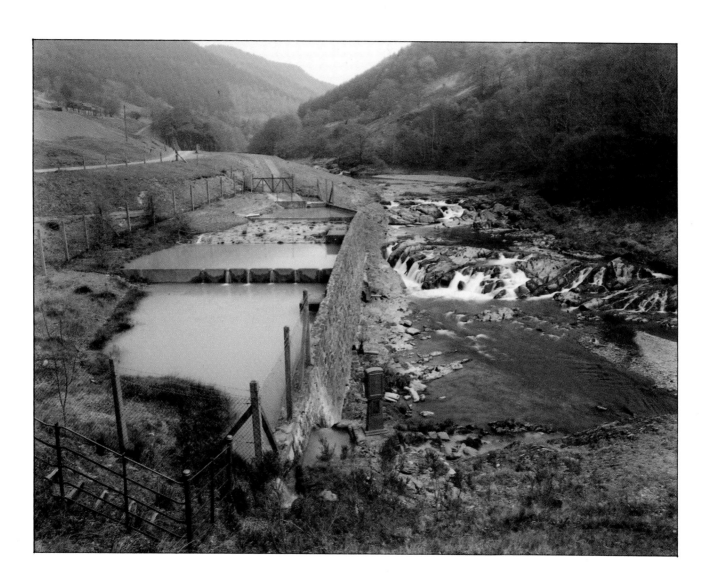

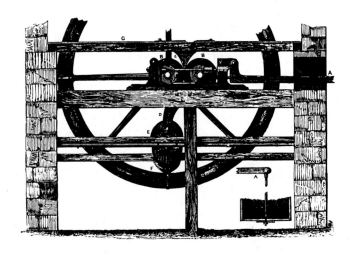

CWM RHEIDOL SN 730 783
19th Century Crusherhouse

From Phillips and Darlington *Records of Mining & Metallurgy*. Note the lever arm A, rolls B, sifter E, raff wheel F, rails for incoming trams C. The buildings were very robust to withstand vibrations and often had staircases as in Cornish engine houses.

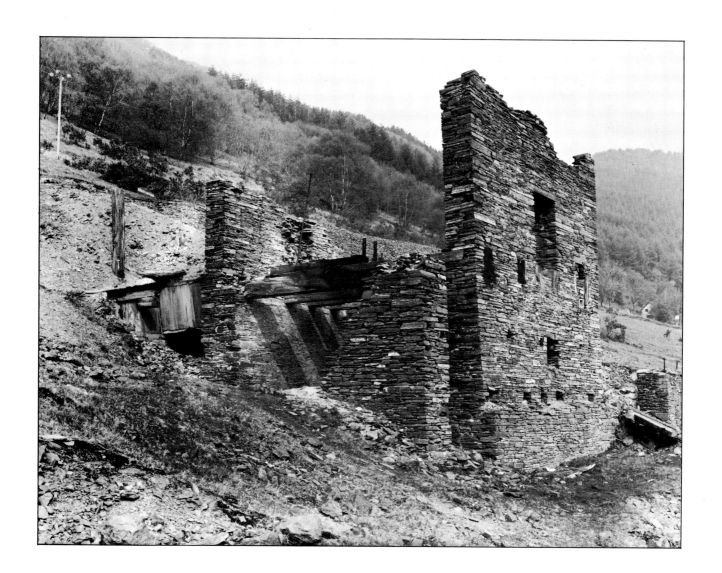

CWM RHEIDOL SN 730 783
Site looking North

The mine was last worked for blende (Zinc Sulphide) from 1900 to 1912. The dressing plant was powered by a turbine by the river and an aeriel ropeway carried ore to the nearby Vale of Rheidol Railway, which still runs along the southern bank of the river from Aberystwyth to Devil's Bridge. The remains of the 19th century crusher house are partly obscured by the later dressing plant. Note the site of the Alderson's 1824 adit to the left of the house at top of the photograph.

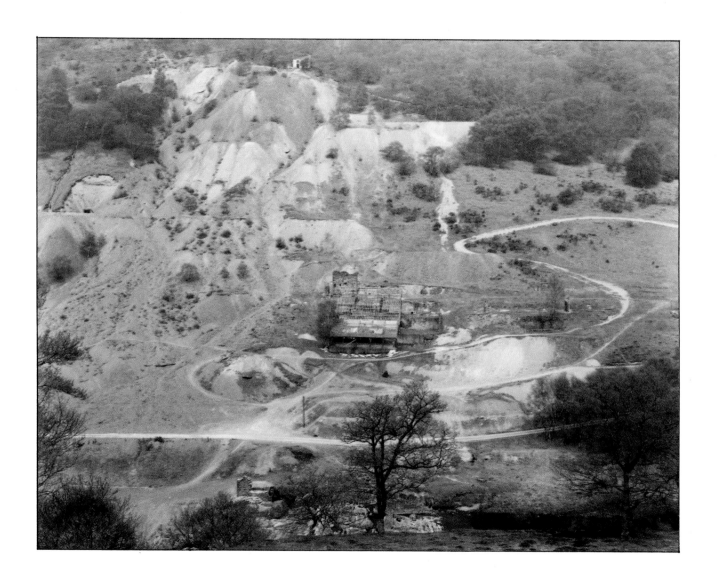

NANTYRARIAN SN 705 814
Two-Way Level

A small very ancient mine, was last worked by the Silver Stream Mining
Company at the turn of the century. This two-way level, a rare feature in
Cardiganshire, was probably driven using the 'fire-setting' technique.

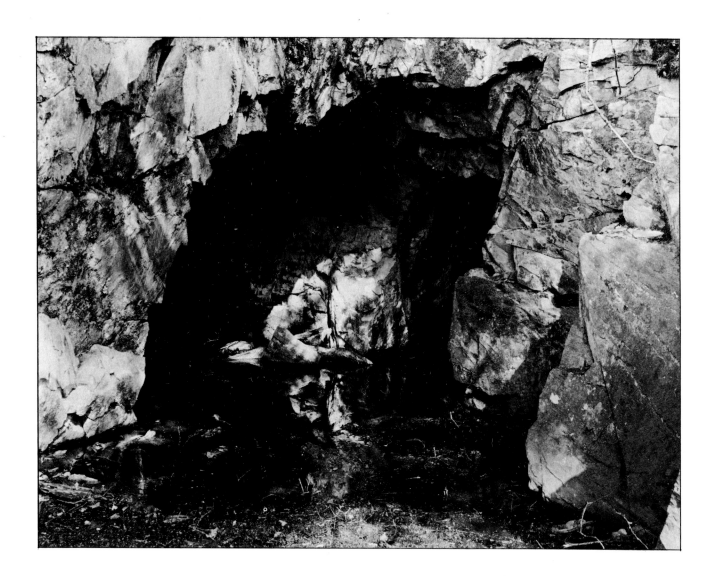

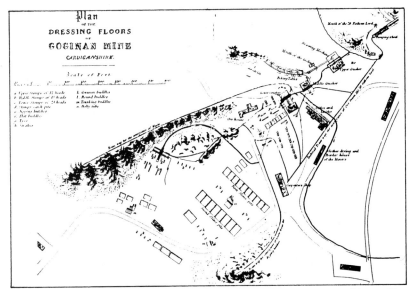

Dressing Floors at the Goginan Mine 1948. (*Mem.Geol.Surv*. 1848, vol.ii, pt.ii).

GOGINAN SN 692 817
Reclaimed Site with Watercourse from old Level

Council landscaping activity has left the entire site void of visual clues to its long and important history. This sort of cleansing action divorces people from their own industrial past and although a hazardous 'eye sore' has been removed from the general public, the problem of resolving a cultural duty has not been tackled. It requires recognition, further thought and imagination, and a lot more money in local coffers.

Goginan was worked with few interruptions from Roman times till 1886. Once a Mine Royal under Mydellton and Bushell, it was mainly worked for silver and in ca.1700 it passed into the possession of The Company of Mine Adventurers. In 1836 John Taylor & Sons took over the workings and advanced development. From 1837-1886 Goginan produced 25,000 tons of lead ore and half a million ounces of silver. In 1877 63 people were employed underground and 57 at the surface.

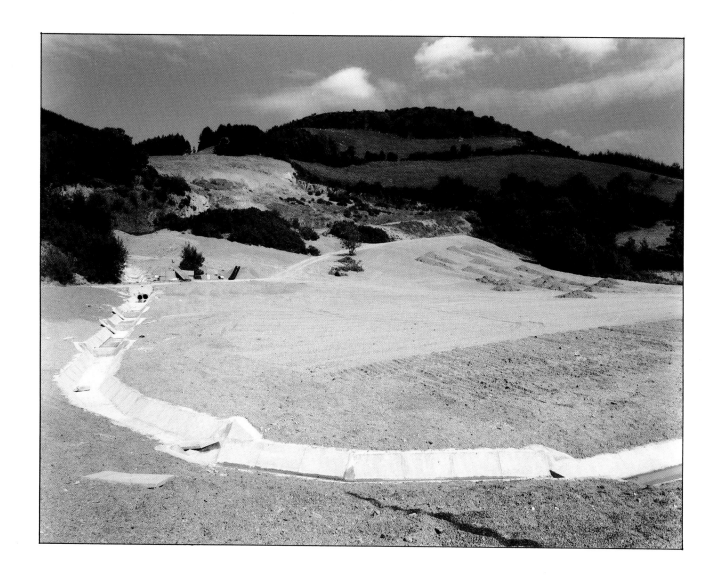

PENCRAIGDDU SN 711 824
c1701 Reservoir on Swampy Plateau

This mine was worked in the 17th century for its silver. The Mine Adventurers leased it in 1701 at a cost of £1000. Mining lore has long associated boggy ground with rich mineral deposits and 'a great body of ore' was discovered between 1710 and 1720.

BRONFLOYD SN 659 835
Cast Iron Waggon Near 1859 Adit

This kind of waggon was used to contain and move ore on rails from face to surface via levels.
They could be horsedrawn, pushed or wound out by an engine. Kibbles were used to raise up ore via shafts. Waggons and kibbles were first made of wood and later of iron.

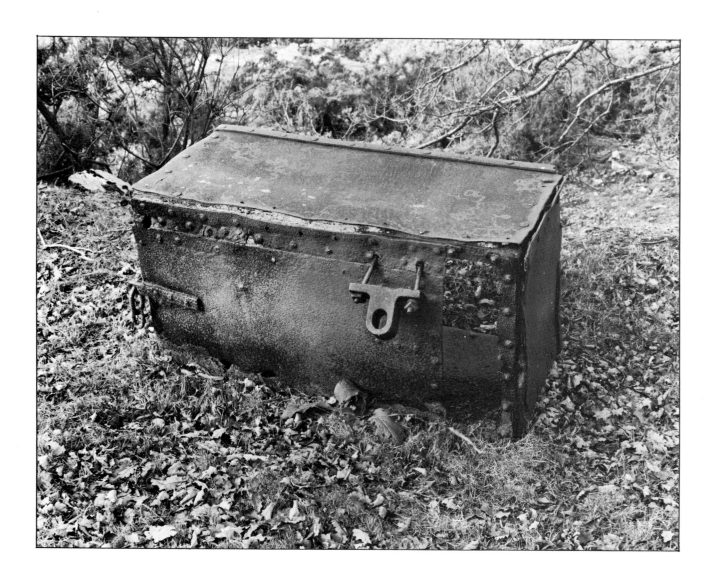

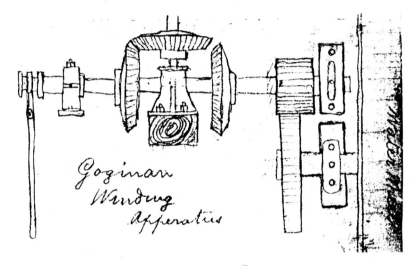

Goginan Winding Apparatus

Primordial Gearbox, 1859 Salop C.R.O.

BRONFLOYD SN 659 835
Drawing Wheelpit with Wrought Iron Axle and Gear Box

The wheelpit housed a water wheel and the adjoining box shaped cavity a gear-changing mechanism. In Bronfloyd this kind of winding engine was used to haul ore from an adit.

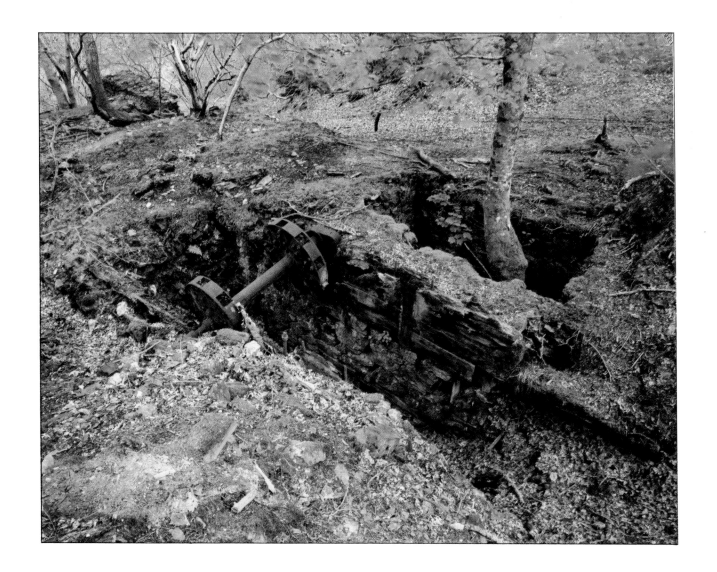

CRAIG Y PISTYLL SN 720 856
Water Outlet to Llawrcwmbach mine (SN 708 854)

The water outlet (SN 713 855) served John Horridge's 1840 leat which conveyed the waters of the Leri to Cwmsebon (approx. 14 miles) via Llawrcwmbach and Llety-Ifan-Hen.
Craig-y-pistyll reservoir was damned in 1880 when John Taylor extended the leat system to increase the overall fall of water.

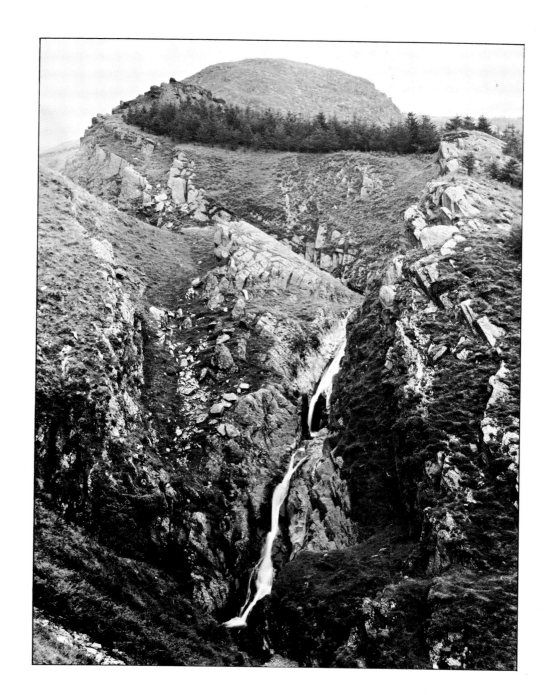

PLYNLIMMON SN 795 856
View of the Site from the Pumping Water Wheel Pit

This mine lies below the highest mountain in Mid Wales at 1800 feet above sea level. The weather could be formidable and for this reason labour was difficult to attract. Mining began in 1866 but was impeded by frequent droughts. Surface water supplies could not be relied on so a steam engine was employed to operate the pumping wheel in a vain attempt to drain the flooded underground workings. Even a reservoir was constructed but its dam burst in 1876 and was never repaired. Plynlimmon was worked intermittently until 1895.

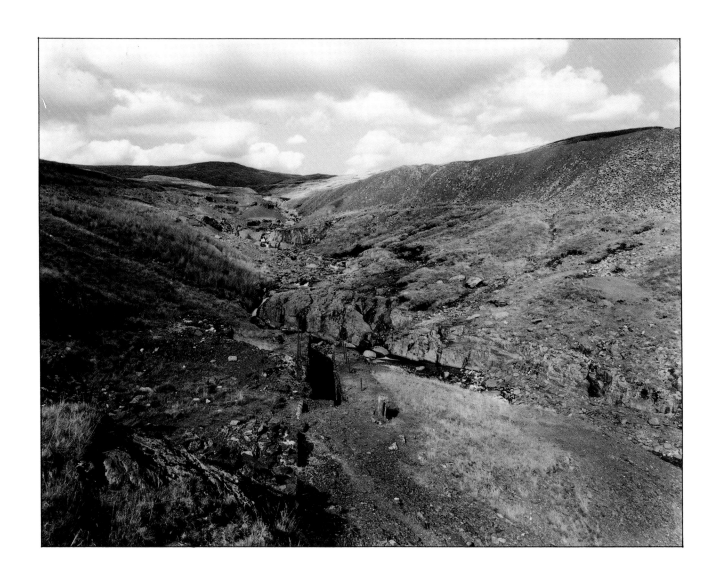

CAMDWRBACH SN 739 886
Nant-y-moch Reservoir from Taylor's Leat

When the reservoir was constructed in 1964 for use in the generating of power for the National Grid, many lead mines were submerged. The site of Brynyrafr mine, last worked in 1912, can however still be seen to the left above the water.

CAMDWRBACH SN 739 886
Dressing Floors and Taylor's Leat on Fainc Fawr

The remaining dressing floors are still visible at the foot of the mountain, Fainc Fawr. They were connected by tramroad not only to the workings at the head of the Camdwr valley but also to Brynyrafr which ore it also processed.

Half-way up the slope of Fainc Fawr Taylor's leat can be seen with the tramroad running parallel at a lower contour. The leat ran from Llyn Fyrddan to Bronfloyd over a distance of 19 miles serving on route 10 mines and 50 waterwheels.

BLAEN CEULAN SN 716 905
Site looking North-West

Amongst the remaining mine buildings is a notable brick lined chamber which
housed the 20 ft. boiler of an engine that provided power for an ore crusher on
the dressing floors. Blaen Ceulan was worked in the 1870's by J. B. Balcombe
who invested heavily in steam (rare in Cardiganshire), including an 8 hp.
engine nicknamed 'Little Wonder' installed underground. Steam, however,
proved uneconomic due to the heavy transport costs of coal, and by 1873 'Little
Wonder' was substituted by a 40 ft. water wheel the outlet of which can be
detected just left of centre of the photograph, with the remains of its wheelpit
above. Copper was also extracted from this mine.

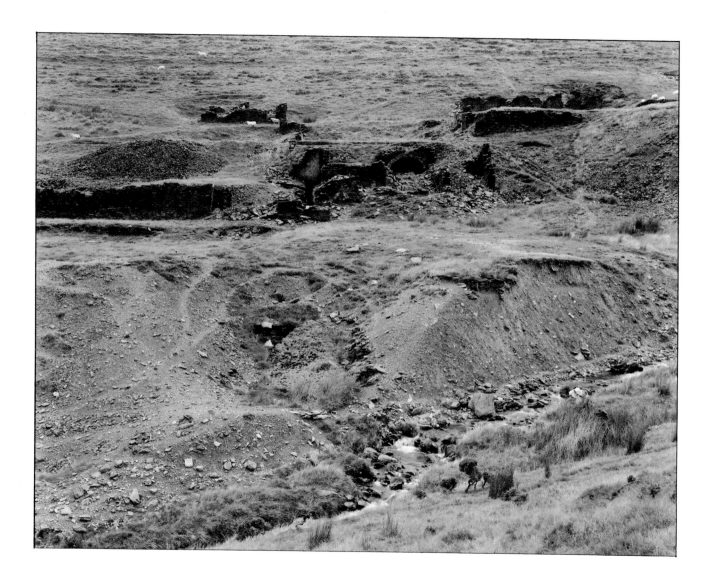

ESGAIR HIR SN 731 912
William Waller's 'Great Work'

The 'Great Shaft' and below it, marked by large spoil heaps, the West level
(now filled in) begun in 1690.

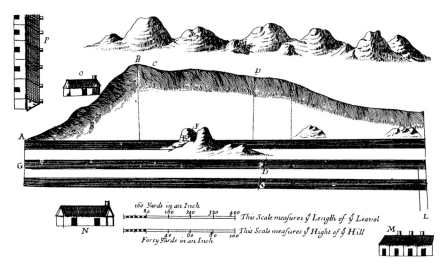

A The West Level. B The Shaft of the great Work. C We are there sinking but being much water'd, we are driving up the East Level Vein from (d) that is in some places above Eight Foot wide in firm solid Ore. Two veins divide at the Mountain E

William Waller's 'Mapp of the Great Lead & Silver Mines of Bwlch-yr-eskir-hir', with an abstract of his description.

ESGAIR HIR SN 735 912
Site Looking West

Esgair Hir was given the name 'Welsh Potosi' by mine agent William Waller in the late 17th century to create associations with the enormously rich silver mines of Bolivia. The remains of the 1872 engine house in the distance are seen from the forestry road built from the spoil heaps on the site. The mound behind the sheep shed is identified as mountain E on Waller's map of the mines 1693.

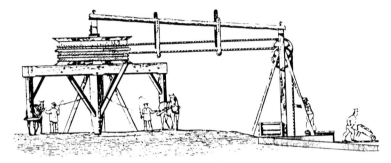

Horse-whim, *c*.1820.

PENSARN SN 668 912
Horse-Whim Circle and Stone Centre-Bearing at the Old Engine Shaft run in (foreground)

An improved horse winding device, the whim-gin, was invented towards the end of the 17 century. Whim-gins or whimseys were used at some small mines in the latter part of the 19th century leaving the circular walk of the horses as evidence.

This new winder had a horizontal rope drum mounted on a vertical shaft. The drum was at a distance from the pit mouth, the rope being suspended over two pulleys. The drum of a whim-gin could be made larger thus giving more power. Some gins were worked by one horse, others by two or more depending on the depth of the shaft and the size of the load to be raised. Typically, the rope drum was nine or ten feet in diameter.

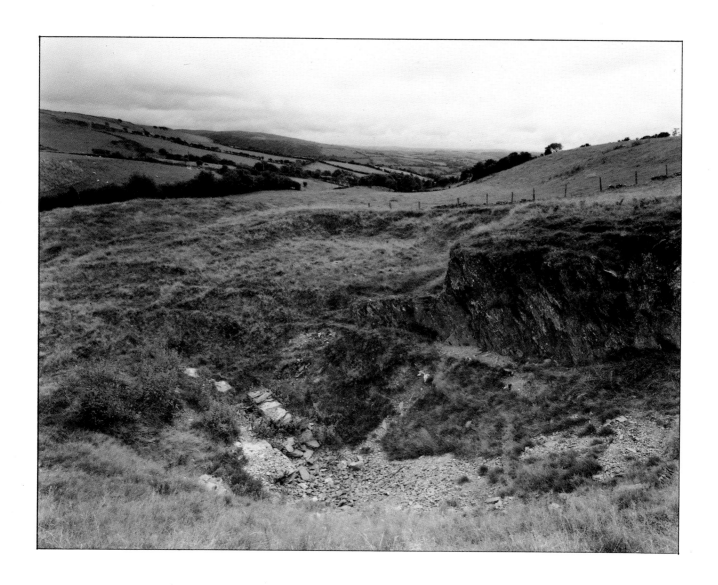

YSTRAD EINION SN 707 938
Site with Crusherhouse, Wheelpit and Water Outlet, and Dressing Floors

Worked in the 1890s for lead, blende (zinc ore) and copper. This site is extremely steep, compact, and engulfed by conifers. It was served by three water wheels on different levels on a line with a water outlet below the centre of the photograph. The platforms in line of descent beneath the crusher house were used for dressing, buddling and jigging. The wooden launder in the foreground conveyed material from the jiggers to slimepits.

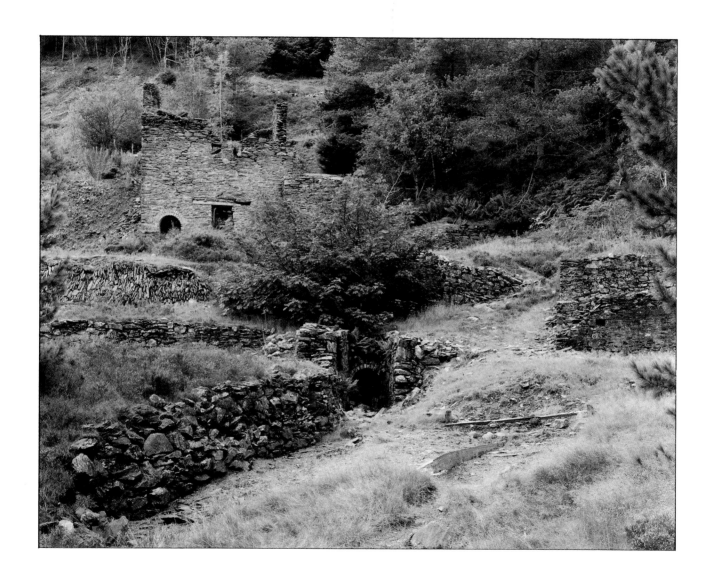

YSTRAD EINION SN 707 938
Powder Magazine

A circular structure, the cone-shaped roof of which has collapsed.

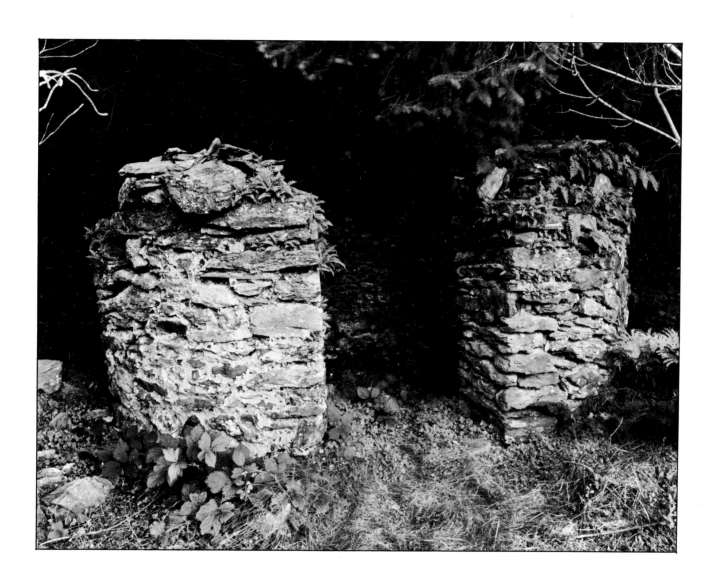

BRYNDYFI SN 683 934
Water Outlet

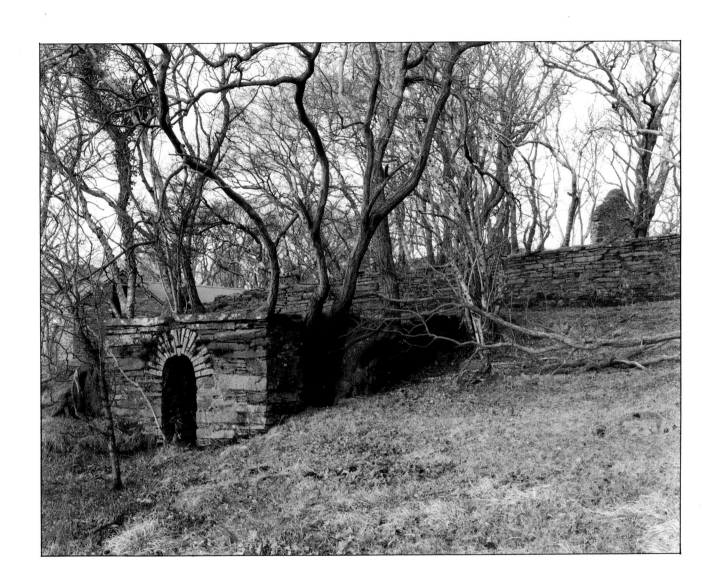

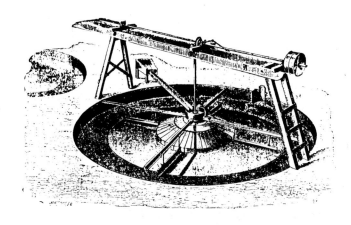

Turned by a small waterwheel, the round buddle was a
favourite in Mid-Wales for extracting ore from slimes, which
were fed in at the centre.

BRYNDYFI SN 683 934
Round Buddles, Wheelpit and Slime Pits

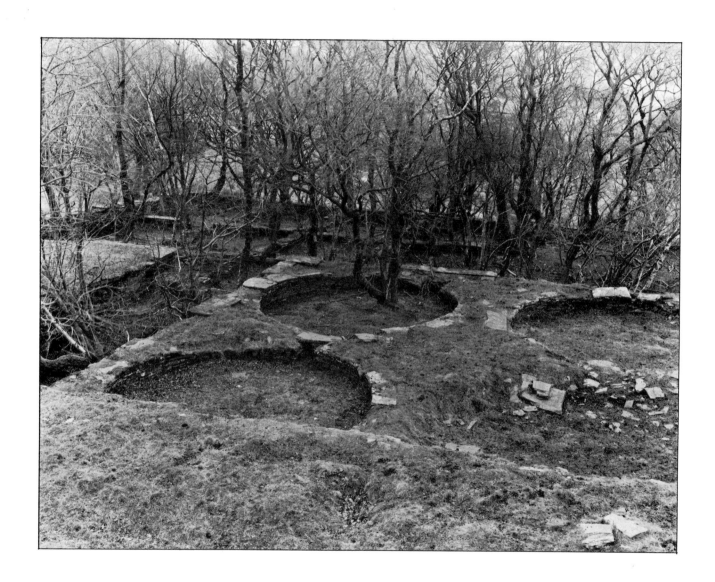

BRYNDYFI SN 683 934
Processing Plant and Ore Bins

Bryndyfi was worked from 1881 to 1883 and is a typical example of overcapitalisation where huge amounts of money were spent at surface before the mine was proved to be rich enough to be exploited. The mine employed 100 men but sold only 24 tons of lead ore.

The site is most explicit with regard to its original function. The mine buildings have been beautifully planned and executed and all other features are still reasonably well preserved.

The south of the site is occupied by the dressing floors, two ore bins, a massive crusherhouse with a 45 ft. wheelpit, four buddles 18 ft. in diameter with an adjoining 22 ft. wheelpit, a set of square stone slime pits, 18 in all, enclosed by a capped stonewall whence protrudes a water outlet to the south.

This part of the mine was connected via tramroad around the hillside to the level and shafts. From south to north a set of three reservoirs has been built in a line ascending the hillside; the middle pond is flanked by an oblong powder magazine to the east.

The plant was designed by D. C. Davies and Sons in the 1880s.

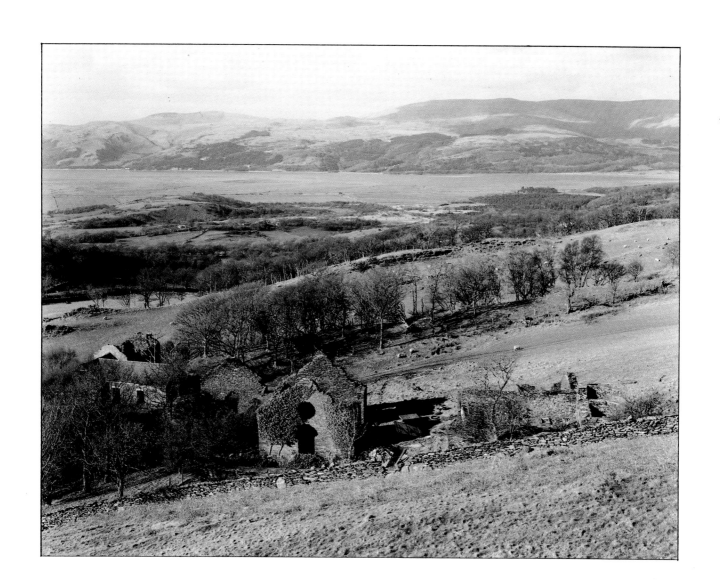

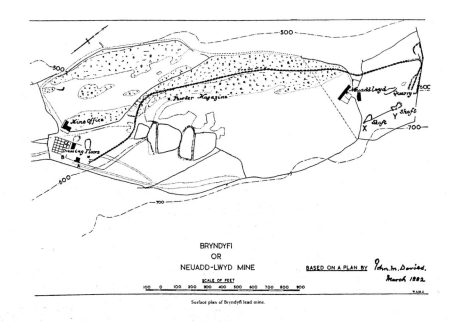

BRYNDYFI
OR
NEUADD-LWYD MINE

BASED ON A PLAN BY *John M. Davies.*
March 1882

SCALE OF FEET

100 0 100 200 300 400 500 600 700 800 900

Surface plan of Bryndyfi lead mine.

BRYNDYFI SN 683 934
Reservoirs with Powder Magazine

100

BRYNDYFI SN 683 934
Level and View North-East with Coed Bwlcheinion

Bibliography

Agricola, G.	**De Re Metallica 1556.** (copy in National Library of Wales.)
Ball, T.K.	**Preliminary mineral reconnaissance of Central Wales.** Institute of Geological Sciences. HMSO 1976.
Bick, D.E.	**The Old Metal Mines of Mid-Wales, parts 1-4.** The Pound House from 1974.
Bick, D.E.	**Frongoch Lead & Zinc Mine.** British Mining No 30. Northern Mine Research Society 1986.
Boon, George C.	**Cardiganshire Silver and the Aberystwyth Mint in Peace & War.** National Museum of Wales 1981.
Clough, Robert T.	**The Lead Smelting Mills of the Yorkshire Dales and Northern Pennines.** Private 1980.
Davies, E.Henry	**Machinery for Metalliferous Mines.** A practical treatise for mining engineers, metallurgists & managers of mines. London 1902.
Faraday, Michael	**Faraday in Wales.** Gwasg Gee, 1972.
Hughes, Simon J.S.	**The Cwmystwyth Mines.** British Mining No 17. Northern Mine Research Society 1981.
Hunt, Robert	**British Mining.** 1884. Crosby Lockwood 1884.
Kinnaird Report	**A Government Enquiry into the conditions in the mines of Great Britain, 1864.**
Lewis, W.J.	**Lead Mining in Wales.** University of Wales Press 1967.
Malkin, B.H.	**The Scenery, Antiquities, and Biography of Wales; from Materials collected during two excursions in the year 1803.**
Palmer, Marilyn	**The Richest In All Wales.** British Mining No 22. (The Welsh Potosi or Esgair Hir and Esgair Fraith Lead and Copper Mines of Cardiganshire.) Northern Mine Research Society 1983.

Pennant, Thomas	**Tours in Wales.** 1783.
Rees, D.Morgan	**Mines, Mills and Furnaces.** HMSO 1969.
Rees, D.Morgan	**The Industrial Archaeology of Wales.** David & Charles 1975.
Richardson, J.B.	**Metal Mining.** Allen Lane 1974.
Sinclair, Catherine	**Sketches and Short Stories of Wales and the Welsh.** 1860.
Trevelyan G.M.	**English Social History.** 1944.
Trevelyan G.M.	**History of England.** 1942.
Warner, Revd.R.	**A Walk Through Wales in August 1797.**
Williams, Stephen	**An Account of the Excavations of Strata Florida.** 1889.
	A History of Technology, Volumes 1-5. Oxford University Press.

All the photographs and original drawings in this book are available as limited edition prints—details on request from Y Lolfa.

Cast Iron Mould for Pig Lead. Found in the Yorkshire Dales.

Also available from Y Lolfa

Symphonies in Black
Nicholas Evans and Rhoda Evans
Heroic, darkly dramatic paintings that evoke the early days of coal
mining in Wales; the historical background is fully described by the
artist's daughter.
0 86243 135 2
£9.95 *hardback*

Snowdonia—Myth and Image
Anthony Griffiths
A photographic study of Snowdonia with reference to Welsh legend and
folklore.
0 86243 276 6
£5.95

Artists in Snowdonia
James Bogle
Thirty canvases by artists who have tried, over the last two centuries, to
capture the beauty and grandeur of Wales' highest mountain range.
0 86243 222 7
£5.95

For a full list of all kinds of publications of Welsh interest, send
now for your free copy of our new 80-page catalogue.

Talybont, Ceredigion, Cymru SY24 5HE
tel (0970) 832 304, *fax* 832 782